on european ground

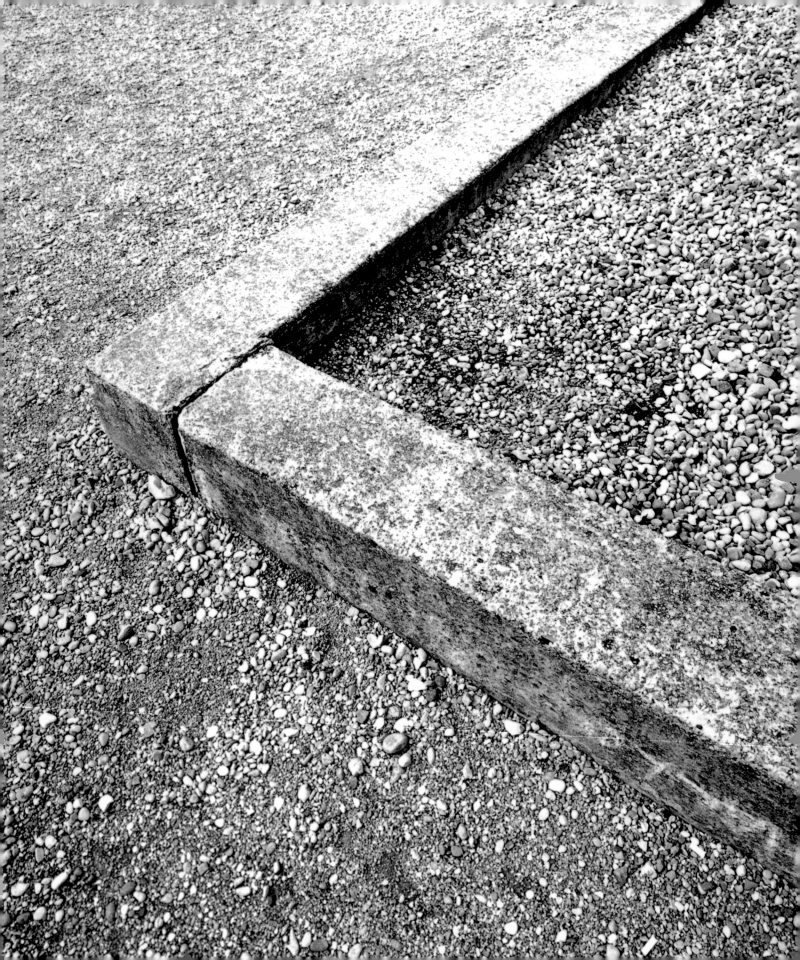

essays by sander l. gilman. jonathan bordo

interview by roberta smith

on european ground

ALAN COHEN

the
university · in association with the
of chicago press, · mary & leigh block museum of art,
chicago and · northwestern university
london

The University of Chicago Press, Chicago 60637

The University of Chicago Press, Ltd., London

© 2001 by The University of Chicago

"Alan Cohen's Surfaces of History" © 2001 Sander Gilman

"Phantoms" © 2001 Jonathan Bordo

Alan Cohen interview © 2001 Roberta Smith

Foreword © 2001 David Mickenberg

09 08 07 06 05 04 03 02 01 00 1 2 3 4 5

ISBN (cloth) 0-226-11294-2

Library of Congress Cataloging-in-Publication Data

Cohen, Alan, 1943–

 On European ground / Alan Cohen ; essay by Sander L. Gilman.

 p. cm.

 Includes bibliographical references.

 ISBN 0-226-11294-2 (cloth : alk. paper)

 1. Europe—Social conditions—20th century —Documentation. 2. Political persecution—Documentation—Europe. 3. Alienation (Social psychology). 4. Photography in historiography. 5. Battlefields—Documentation—Europe. 6. Atrocities—Documentation—Europe. 7. Holocaust memorials. 8. Documentary photography. 9. Holocaust, Jewish (1939-1945). 10. National socialism—Moral and ethical aspects. I. Gilman, Sander L. II. Title

D424.C58 2001

940—dc21 00-011972

FOR SUSAN

"[T]he Jewish history of [Germany] is not separable from the

history of Modernity, from the destiny of this incineration of history;

they are bound together. But bound not through any obvious forms,

but rather through a negativity; through an absence of meaning of history and an

absence of artifacts. Absence, therefore, serves as a way of

binding in depth, and in a totally different manner."

DANIEL LIBESKIND, COUNTERSIGN

contents

foreword

In *The Clothing of Clio*, author Stephen Bann introduces the idea of the *ironic museum*, one in which the multiple and often contradictory readings or versions of art are presented. It is a notion that, in many respects, embodies the purpose of a university museum. In the juxtaposition of images, in the displacements caused by the museum environment, and in the perspectives arising from new views of the commonplace, history and its attending issues of identity and memory can be approached with fresh understanding.

In such an environment, Alan Cohen's work stands out not only as singularly important but necessary. The subtle border between narrative and abstraction in his photographs, their complex negotiation of reality and memory, are couched in an aesthetic vocabulary that challenges our sense of the meaning of photography and photography's role in the museum. Neither journalistic in nature nor narrative, the images in *On European Ground* provide a point of departure. They help define present identities by referencing the political, military, and economic traumas that have enveloped Europe in the twentieth century. The photographs speak as much to what is remembered as what is forgotten and how

memory and forgetting influence our perspectives of the past. It is for these reasons that the Mary and Leigh Block Museum of Art has for many years collected Alan Cohen's photographs and has joined with the University of Chicago Press in presenting *On European Ground* to the public. We are deeply grateful to Alan Cohen for making this project possible.

DAVID MICKENBERG, DIRECTOR
MARY AND LEIGH BLOCK MUSEUM OF ART
NORTHWESTERN UNIVERSITY

SANDER L. GILMAN

alan cohen's surfaces of history

In Berlin there is an exhibition called the "Topography of Terror." In 1987 a builder excavating near the Wall in West Berlin accidentally uncovered the cellars of the buildings occupied by Heinrich Himmler's SS headquarters from 1933 to 1945. In those closed and hidden spaces unspeakable horrors took place. There cheek by jowl were the offices of the Secret State Police (and the Gestapo "house prison"), the SS Reich leadership, and the Reich Security Main Office. The bombing and shelling of Berlin in 1944 and 1945 leveled the buildings, and the reconstruction of Berlin in the late 1940s buried their ruins. All that remained were the filled-in cellar spaces, now exposed to view.

Slowly, over the past decade, what began as an excavation was transformed into a temporary exhibition space for documents related to the Third Reich. The Topography of Terror is now expected to become a permanent museum dedicated to keeping alive the memory of Nazi horror. This would be one of the new buildings intended to mark the beginning of the "Berlin Republic," the new Germany of today.[1]

But imagine with me this piece of ground before the bulldozer turned its first bit of earth, uncovering the bricks and mortar in the Prince Albrecht Plaza. As a student I had walked there many times. I remember it first as an overgrown field.

1. Topography of Terror Foundation (www.topographie.de/e/ort.htm).

{ 1 }

The uneven earth was much like other green, weedy lots that were present all over Berlin in the early 1960s. Later when I returned to the States and began to teach in Cleveland, large areas of that city looked to me strikingly similar. They had been cleared in the "urban renewal" that followed the 1966 riots.

It was clear that at one time something manmade had existed there. The emptiness of the green lots of Berlin and Cleveland could not altogether hide the fact that these were scenes of violence, of ruins only recently cleared. Even more famous Romantic landscapes have barely concealed a violent and ruined aspect. William Wordsworth's field "of golden daffodils; / Beside the lake, beneath the trees, / Fluttering and dancing in the breeze" put him "in pensive mood" because it was only miles from the encroaching wastes of the Industrial Revolution. Wordsworth's fields themselves had been farms until the small landholders were driven away by land reform not a generation before. Abandoned landscapes, urban or pastoral, mask even as they reveal.

As a student wandering in Berlin I knew that the "Trummerberg," that huge mountain forest on the northern edge of West Berlin, now overgrown and pleasant, was the dumping ground of the ruins of the city. Any competent archaeologist wandering an ancient site can read the terrain and tell you whether a hill is a natural hill or a Tel, the repository of thousands of years of habitation. The ability to scrutinize the ground at your feet, to read history through the veil of earth or even in its surface, is a skill to be cultivated—and an obligation.

Satellite photographs now allow us to trace "disturbances" of the earth from hundreds of miles above. In his brilliant novel *Underworld* (1997), Don DeLillo describes how his protagonist becomes mesmerized by his ability to read the surface of the earth in images taken from the distance of space:

The pictures . . . revealed signs of soil erosion, geological fracture and a hundred other events and features. They showed stress and drift and industrial ravage . . . converted into images. He saw how remote sensors pulled hidden meanings out of the earth. How . . . rorschach pulses of unnamed shades might indicate a change in water temperature or where the dwindling grizzlies go to forage and mate. He looked at spindly barrier beaches that showed white as shanked bone. He found sizable cities pixeled into mountain folds and saw black lakes high in the ranges, kettle holes formed by glacial drift.

He could not stop looking.

The photo mosaics seemed to reveal a secondary beauty in the world, ordinarily unseen, some hallucinatory fuse of exactitude and rapture. . . .

And he thought of the lives . . . embedded in the data on the street that is photographed from space.[2]

2. Don DeLillo, *Underworld* (New York: Scribner, 1997), p. 415.

What is there in an image of earth that grabs our attention and keeps us looking? What do we find so intriguing about the object of our scrutiny? And how can we learn to decipher its meaning?

Hanging in Alan Cohen's Chicago studio are two lunar photographs: a broad moonscape as seen from Apollo 15 (26 July–7 August 1971) and probably made by David Scott, and a moonscape with instruments likely made by Harrison Schmitt on the Apollo 17 mission (7–19 December 1972). These and other lunar photographs that he has tucked away have exerted a strong pull on Cohen, and they suggest one line of influence for the photographs in *On European Ground*. It is the combination of the simple beauty of these images and the immense complexity of their making that fascinated him. The Apollo photographs were not intended to have an aesthetic dimension. They are "scientific" photographs, taken to record the progress of a mission and indeed to prove that we reached the moon and left our "mark" there. And yet for all their apparent neutrality, these are evocative images, describing in uncanny detail the traces of our fleeting presence on the barren lunar surface.

Alan Cohen's photographs, like the lunar photographs of the Apollo missions, recall the intersecting traditions of early industrial, survey, and tourism photography. But conceptually and stylistically they owe less to these nineteenth-century topographic traditions than to the abstracted forms of Man Ray or the Dada photography of Georg Anthiel. Cohen's gradations of gray and black often register first as abstractions in a way László Moholy-Nagy would have embraced as "modern" in the Weimar Bauhaus or indeed in his New Bauhaus at Chicago's Institute of Design. These images are also modern, however, in quite a different sense. Cohen's project is to explore, at the end of a century of mass death, how to represent historical trauma

in a manner true to our own moment. His photographs address three pivotal moments of the twentieth century and the places that defined them: World War I and its battlefields, the Shoah and its camps, and the Cold War and its icon, the Berlin Wall. Each of these sites has a visual history in the West, each has a place in our imaginations, which Cohen answers through his pedagogy of the historical gaze.

We need to recognize the contours, planes, and sculpted spaces of Cohen's photographs as "natural forms" in a terrain disturbed, destroyed, reconstructed, and buried. Our present footsteps on the battlefields of Europe, at the death camps, along the path of the Wall again mark the thin cover of dust or stone, as did those of the first men on the moon. Asphalt streets, gravel paths, damp leaves on stone paving—these surfaces are our present moment. And yet this ordinary present is literally shaped, as Cohen's images reveal, by a traumatic past. Cohen's gaze reveals to us a missing world—a landscape of death and destruction—in our own place and time. Slowly, photograph after photograph, he unravels our perceived sense of these places. Surfaces of the present collapse into the horrors of the past without any attempt at reconstruction.

Cohen's images evoke precisely what Erwin Panofsky stressed as the hidden problem of the traditional pastoral landscape. Concealed within such classical landscapes always are the memories of death. For Virgil in the fifth *Eclogue* it was the death of Daphnis, which, as Panofsky notes, echoes through his text only "through the elegiac reminiscences of his survivors, who are preparing a memorial ceremony."[3] Hers is the first tomb to be erected in Arcadia. "Et in Arcadia ego": Even in Arcadia I am there, says Death. Cohen's landscapes, especially those of the Somme and Verdun, appear bucolic, and even the images from the camps and his cityscapes can seem to share a similar sense of the abandoned and the untouched. And yet each hides within itself the material memory of the past. The *memento mori* in Cohen's photographs come to be inscribed not in the form of the symbolic skull or scythe but in the undulations and striations of the earth.

3. Erwin Panofsky, *Meaning in the Visual Arts* (Garden City, N.Y.: Doubleday, 1955), p. 353.

From Otto Dix's paintings made during and shortly after the war to Stanley Kubrick's 1957 film *Paths of Glory*, our image archive of World War I emphasizes

the trenches as the site of horror and suffering. It was the trenches that transformed the land itself into an extension of the machinery of war, swallowing men and ordnance into their depths. The violence with which artillery churned the terrain of the Somme, Verdun, and other battlefields is suggested in a passage from Erich Maria Remarque's *All Quiet on the Western Front:*

The front is a cage in which we must await fearfully whatever may happen. We lie under the network of arching shells and live in a suspense of uncertainty. Over us, Chance hovers. If a shot comes, we can duck, that is all; we neither know nor can determine where it will fall.

It is this Chance that makes us indifferent. A few months ago I was sitting in a dug-out playing skat; after a while I stood up and went to visit some friends in another dug-out. On my return nothing more was to be seen of the first one, it had been blown to pieces by a direct hit. I went back to the second and arrived just in time to lend a hand digging it out. In the interval it had been buried.[4]

4. Erich Maria Remarque, *All Quiet on the Western Front*, trans. A. W. Wheen (New York: Fawcett, 1982), 101.

What is left after eighty years? The memorials, to be sure, but also the battlefields themselves, greening yet still disfigured, laden with unexploded shells. As happened shortly after the American Civil War, the battlefields of France and Belgium became tourist sites, with guided motor tours taking visitors among the now quiet trenches and returning them to four-star hotels with first-rate cuisine. (For Karl Kraus, the Austrian critic, it was satire enough simply to reprint the ads for such tours in his review *The Torch* during the early 1920s.) Today the tourists are few, and the handful of living veterans are too infirm even to attend official commemorations. Alan Cohen's photographs meditate on the distance that now separates us from the carnage of the Somme and Verdun, even as they show us that the battlefields are still oddly alive. Bits of machine, of shells and barbed wire, and of bone unearth themselves, like a splinter working itself through the surface of the skin. The wounds here can never be truly covered.

It is in the wounds of World War I that historians have sought the origins of World War II and the Shoah. Common wisdom holds that the loss of the war and the resulting collapse of German identity as well as the German economy meant that

Hitler inevitably followed. True or not, this causal chain is broken in recent cultural representations of the Shoah. In these accounts the Shoah seems *sui generis*, without predecessors or context. It is only geography, the fact that World War I and the Shoah happened at the same physical space, that forms the unspoken continuity.

Claude Lanzmann's 1985 film *Shoah* is one of those accounts, a work close in sensibility to Alan Cohen's project. The film focuses on the present existence of the survivors as an avenue to the horrors of the past. The link between past and present is the land. *Shoah* opens with the survivor Simon Srebnik on a boat near Chelmno, filmed against a background of rolling, verdant hills. He is then shown climbing a hillock at the site where the town's Jewish inhabitants were taken out and shot: "It's hard to recognize, but it was here. They burned people here. . . . No, I just can't believe it. It was always this peaceful here. Always. When they burned two thousand people—Jews every day, it was just as peaceful. No one shouted. Everyone went about his work. It was silent. Peaceful. Just as it is now."[5] Cohen, like Lanzmann, would have us look for the past in the fragments of our own world. In this Cohen and Lanzmann differ from a filmmaker like Steven Spielberg, who relies on the emotional impact of pictures we already recognize, or even from an artist like Anselm Kiefer, whose landscapes likewise evoke the past by drawing on a stock of received imagery. Cohen and Lanzmann eschew the visual archive of the Shoah and the pitfall of easy identification. They insist that we struggle to remember precisely from the ground on which we stand, "Just as it is now."

Jurek Becker's great novel of the Shoah, *Jacob the Liar* (1969), begins with the voice of a survivor-narrator after the Shoah explaining to us how today nature itself has become history: "I can already hear everyone saying. A tree? So what's a tree—a trunk, leaves, roots, some beetles in the bark, and a shapely crown at best; so? Don't you have anything better to think about to give you that rapturous look like a hungry goat being shown a nice juicy bunch of grass?" This tree is the tree of life, but it is also, perhaps, the tree under which a few years later the narrator's wife was executed. "I can't say what kind of tree that one was, I wasn't there, I was just told about it, and I forgot to ask about the tree."[6] Becker's tree is like the tree that stood in the middle of the camp at Buchenwald; the tree to which Goethe a hundred and fifty years before putatively dedicated a poem and which the inmates

5. Claude Lanzmann, *Shoah: An Oral History of the Holocaust: The Complete Text of the Film;* with a preface by Simone de Beauvoir and English subtitles of the film by A. Whitelaw and W. Byron (New York: Pantheon Books, 1985), p. 3. See Margaret Olin, "Lanzmann's *Shoah* and the Topography of the Holocaust Film," *Representations* 57 (1997): 1–23.

6. Jurek Becker, *Jacob the Liar*, trans. Leila Vennewitz (New York: Arcade, 1990), pp. 1–2.

saw daily. Becker, who was seven when he was freed from Ravensbrück, captures the fantasy of the camp as understood by a child. A tree in the Lodz Ghetto or in Ravensbrück must have been a magical object for him, colored by its very improbability in the world of the camps. Like Cohen and Lanzmann, Becker is constrained to begin his account of the Shoah in the present, looking at the world, the trees, the trace of the past as inscribed in the book of nature, now become the book of history. But it is a book written in a script extremely difficult to decipher.

Nature has "repaired" the physical reality of the camps. The buildings rot; the grass covers the Appelplatz (where the inmates assembled each morning and evening). Many of the camps are sinking beneath the grass as fully as the battlefields. In 1945, many of the camps were put to new uses: in the West to hold displaced persons, in the East to hold political prisoners. Only in the case of a few immediately notorious camps—such as Dachau, Buchenwald, and Auschwitz—was there an attempt to preserve the sites as monuments and then museums. But even here, fifty years of visitors of all sorts have caused the camps to deteriorate at a rapid pace. Paths need to be fixed, buildings need to be maintained, even ruins need to be shored up, and yet any plan to restore the camps raises profound dilemmas. This is one important subtext of Cohen's camp photographs: they pose anew the question of whether and how we preserve our past in the present. The great sociologist of the Shoah, Zygmunt Bauman, claims that most of our contemporary attention to the Shoah is apotropaic, a magical gesture to avoid the repetition of the past.[7] Cohen's photographs belie this, for they insist on addressing the Shoah in the experience of our own world.

7. Zygmunt Bauman, *Modernity and the Holocaust* (Ithaca: Cornell University Press, 1989), p. 88.

For Americans, the Berlin Wall symbolized the Cold War and all that was at stake in it. Americans reading the Cold War spy novels or watching films such as Martin Ritt's 1965 adaptation of John le Carré's *The Spy Who Came in from the Cold* learned to see the Wall as the sinister emblem of the immediate conflict with Communism. But for Germans, the Wall signified the evil of the past visited upon the present. Edgar Hilsenrath, a German Jew and a teenage survivor of the Shoah, returned to West Berlin in 1975 after living as a post-Shoah exile in Palestine and

then in New York. His book of novelistic dialogues, published in 1983, relates the commonplace that the Wall owed its existence not merely to Cold War politics, but to the politics of the world of the Shoah:

Hey Mr. Tour Director! Is this Berlin?

This is Berlin!

And that over there?

That is our Wall!

Our common wall?

Yup.

The Berlin Wall?

Nope.

What is it then?

The German-German Wall!

But it's low!

Appearances deceive.

You think.

Yup.

How high is it?

It's very high.

As high as the sky?

Even higher.

How high?

All the way to the horizon that marks an easing of tensions.

The easing of tensions among the super powers?

Yup.

Pretty dangerous height?

You're right.

Could easily collapse.

Perhaps.

Mr. Tour Director!

Yup.

Do you happen to know who built the Wall?

Of course.

Who?

Adolf Hitler.

Wasn't he a house painter?

Nope.

Was he a mason?

Nope.

Not a mason, a master mason?

Nope.

What was he?

A cemetery architect.

Of course.[8]

8. Edgar Hilsenrath, *Zibulsky oder Antenne im Bauch* (Dusseldorf: Claasen, 1983), pp. 11–12.

Hilsenrath expresses here the sense of many Germans, especially German Jews, that the Wall, though built in 1961, somehow embodied the Nazi defilement of the city, a sort of political *Nachträglichkeitseffekt*, a late symptom of a trauma experienced during the 1930s and '40s.

Nor did the fall of the Berlin Wall in 1989 erase its association with the Shoah. In her 1992 novel *Merryn*, the German Jewish writer Esther Dischereit has her sixteen-year-old protagonist, finally able to cross to western Berlin, visit the neighborhood of her grandparents, who were murdered in the camps:

Penzlauer Allee? The fall of the Wall, the collapse . . . Should she reclaim the "Jewified" apartment of her grandparents? The time has passed. The sewing room in the back, iron, chairs, table, commode, and the usual china. Value: 800 Reichsmarks, it's in the files. Infested with vermin is checked off. 10 March 43 on the file, under it the number of the deportation. The Auschwitz deportation.[9]

9. Esther Dischereit, *Merryn* (Frankfurt: Suhrkamp, 1992), p. 77.

The new, reunified Berlin brings back the material reality of the past, the apartment of the protagonists' grandparents, but also a sense of the horrors of that past summarized by the word Auschwitz. Even dismantled, a boundary finally to be crossed, the Wall remains a sign of German guilt. If the Shoah was the Jewish wound on the German body, it is now to be read in the scar of the Berlin Wall. Alan Cohen's Berlin photographs record the presence of the Wall in its absence.

He shows us the fissures, the patches, the surreal junctures and disjunctures that currently mark the Wall's path. Streets and subway lines now knit the two halves of the city together. But the scar of the Wall, the "Wall in the head," has proven stubborn. A sense of separation, of different histories and different presents, haunts Berlin more today, more than a decade after the Wall fell, than at any time in recent memory.

Cohen's photographs expose to us the subtle and organic presence of multiple pasts in our present world. He has written that "The idea of Dachau is white-hot, but Dachau itself is something emptied, even mundane. Dachau has been transformed from a site of unrelieved violence into a landscape that is precisely and justifiably useless. This is earth layered by human and geographic history of a radical and horrific nature." This is equally true of the battlefield at Verdun or the Berlin Wall. What is revealed in learning to read Cohen's photographs is our own sense of surprise that the world in its unseen details is so much shaped by the past. Cohen's gift to us is to show us how to comprehend traces of history that are more radical than any of the inherited images that populate our mental archive, that are no less radical for being ubiquitous and humble.

{ P H O T O G R A P H S }

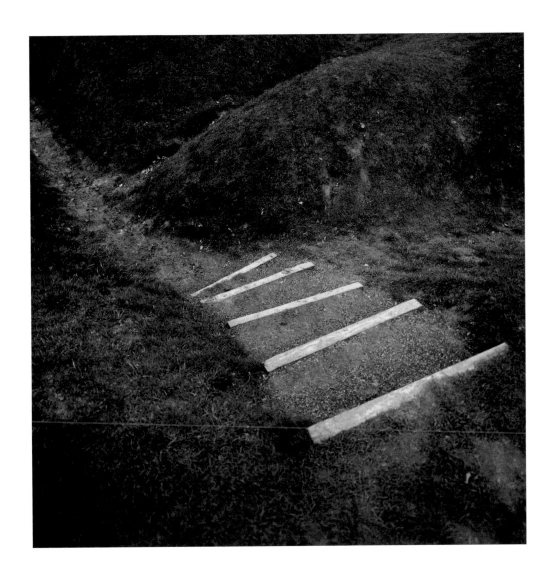

SOMME, 1998

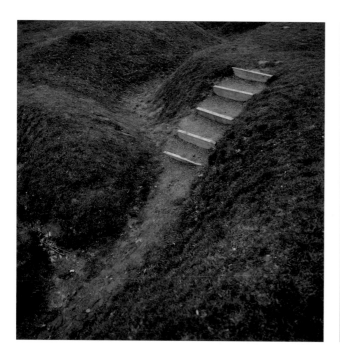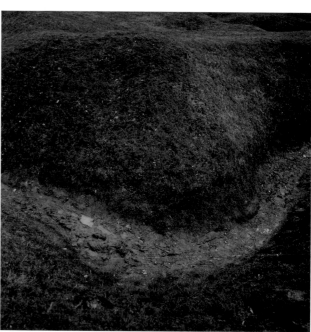

SOMME, 1998

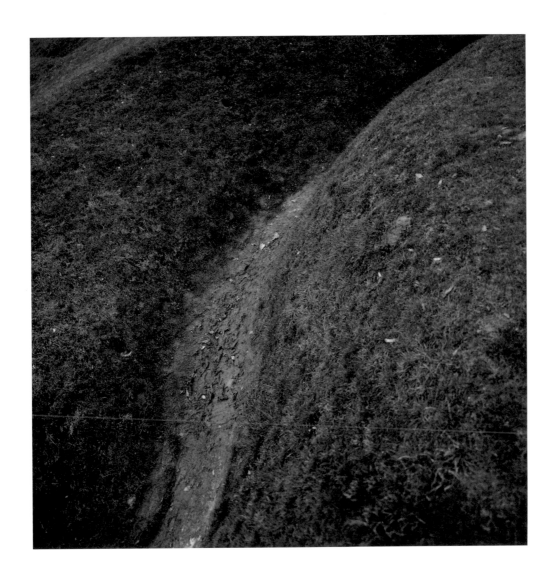

SOMME, 1998

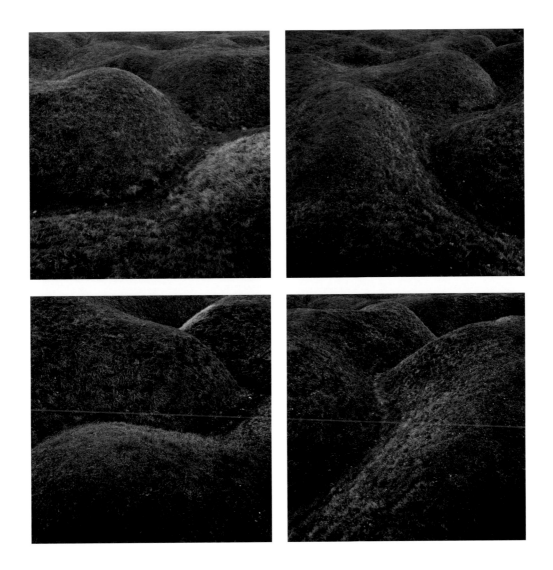

SOMME, 1998

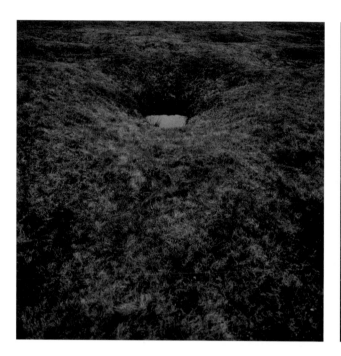
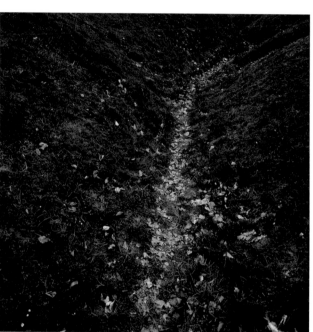

SOMME, 1998

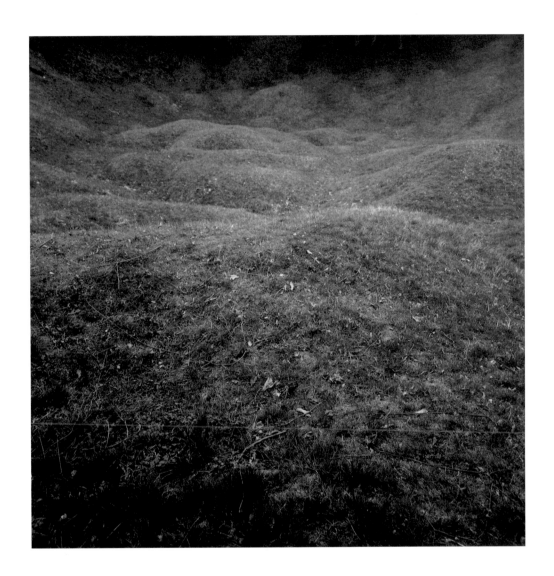

SOMME, 1998

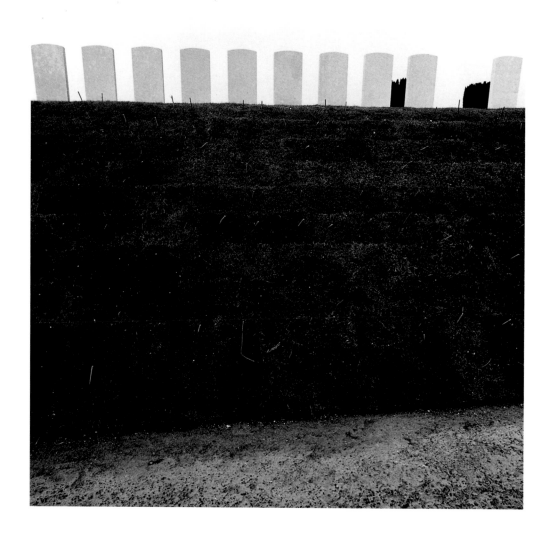

SOMME, 1998

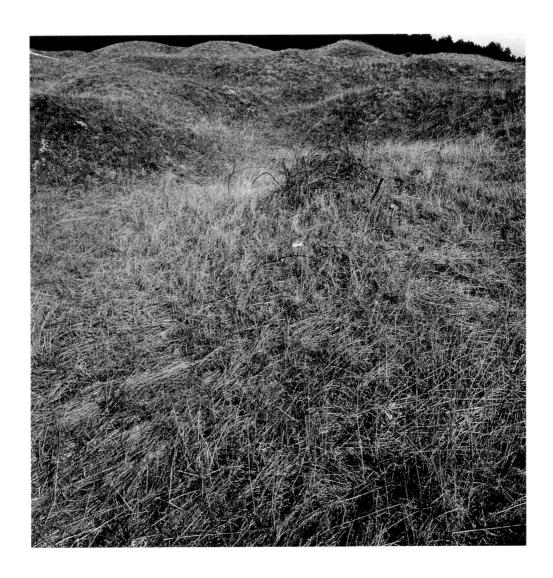

VERDUN, 1998

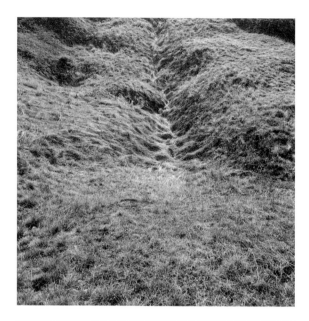

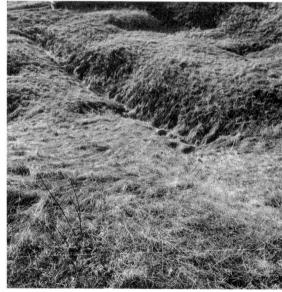

VERDUN, 1998

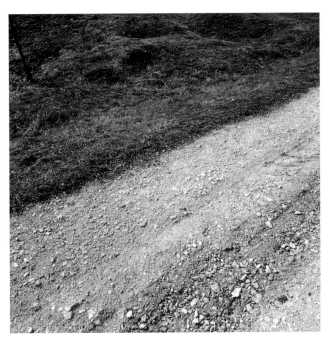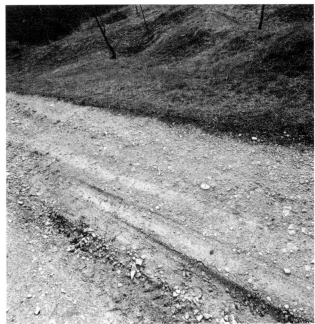

VERDUN, 1998

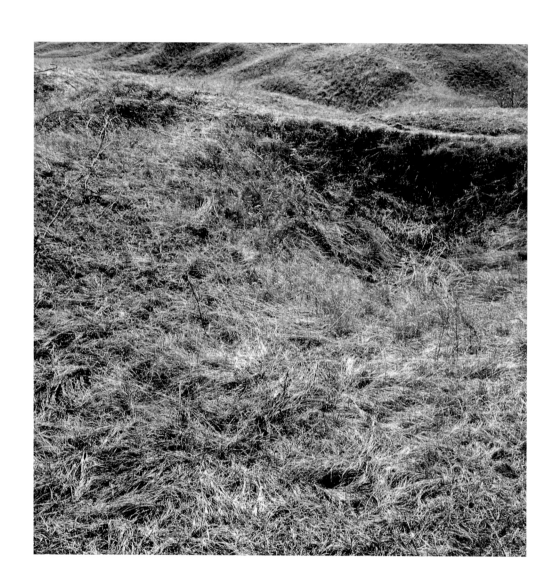

VERDUN, 1998

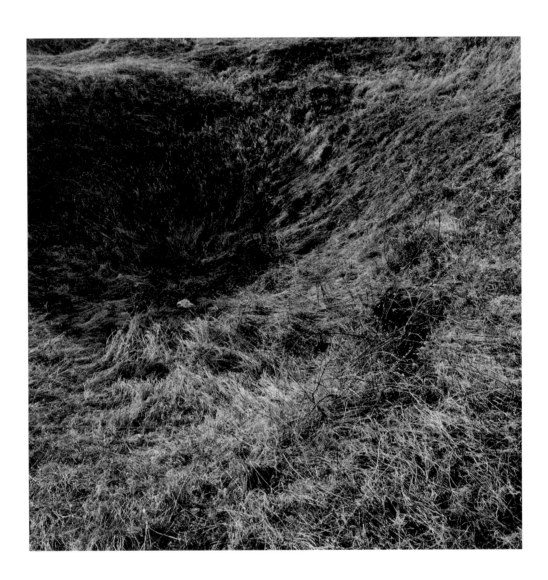

VERDUN, 1998

$\left(\dfrac{24}{25}\right)$

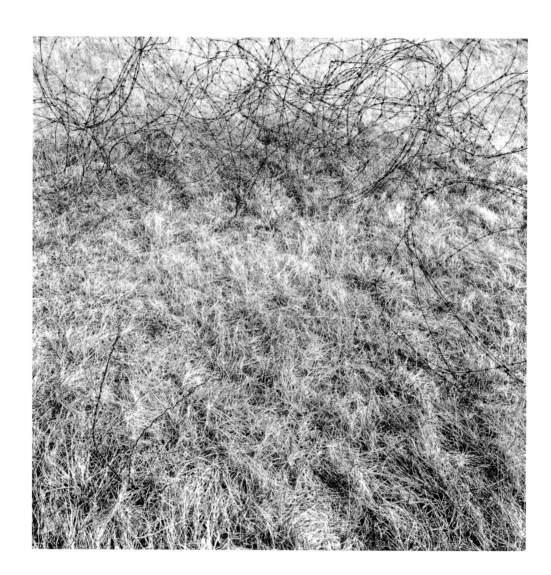

VERDUN, 1998

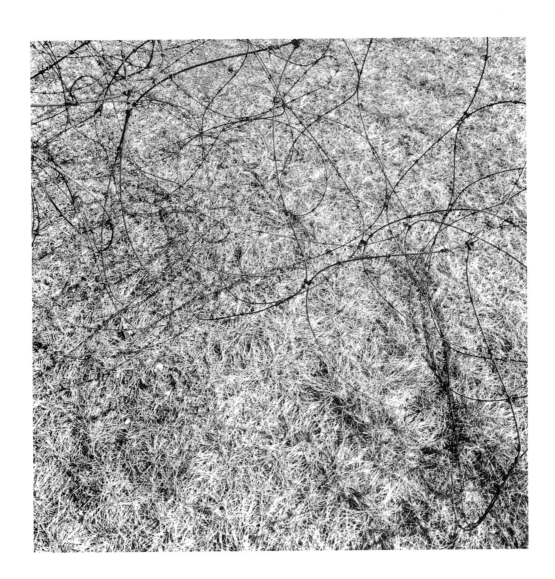

VERDUN, 1998

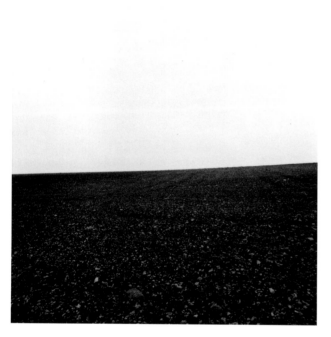
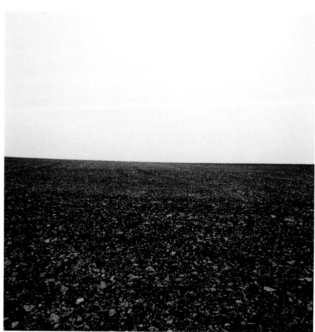

VERDUN, 1998

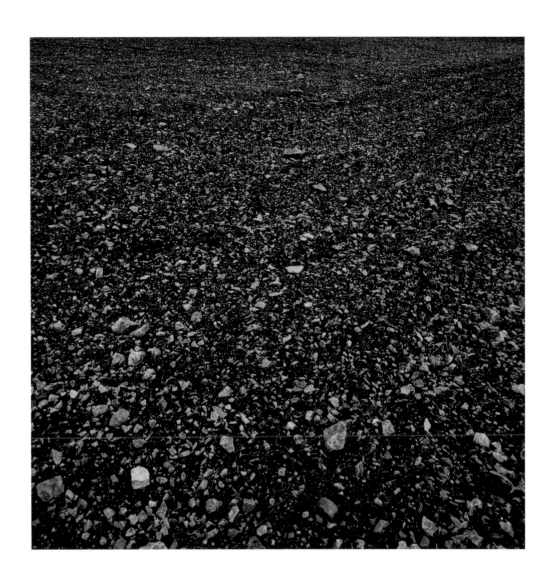

VERDUN, 1998

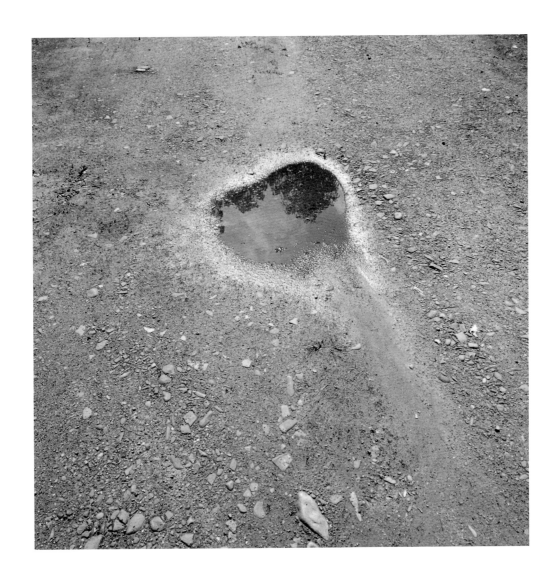

AUSCHWITZ, 1994

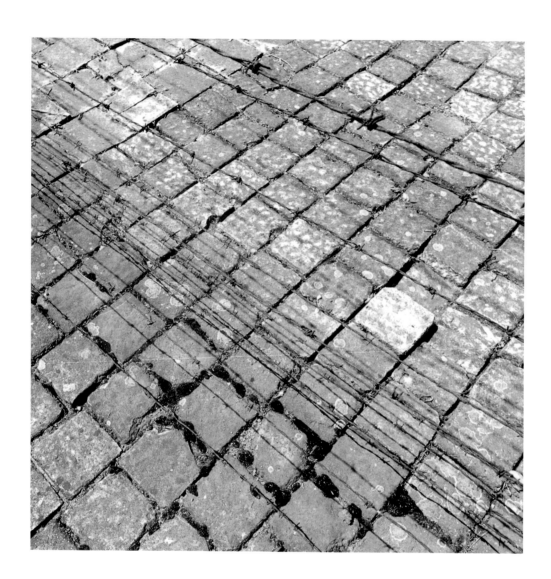

AUSCHWITZ, 1994

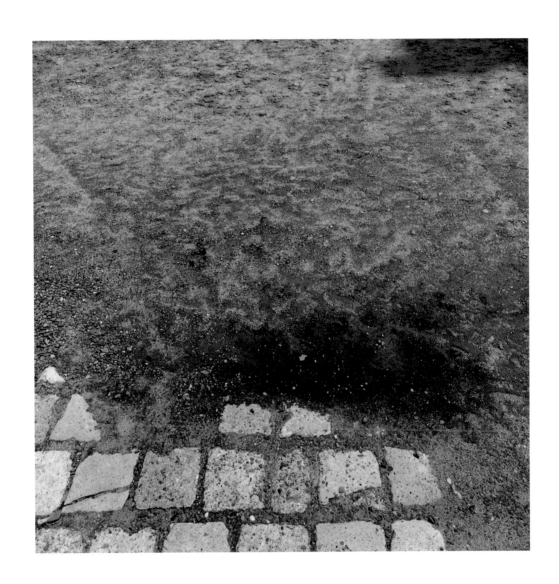

AUSCHWITZ, 1994

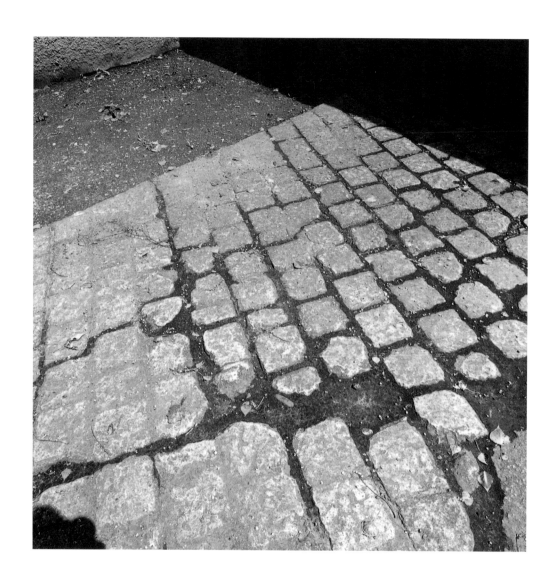

AUSCHWITZ, 1994

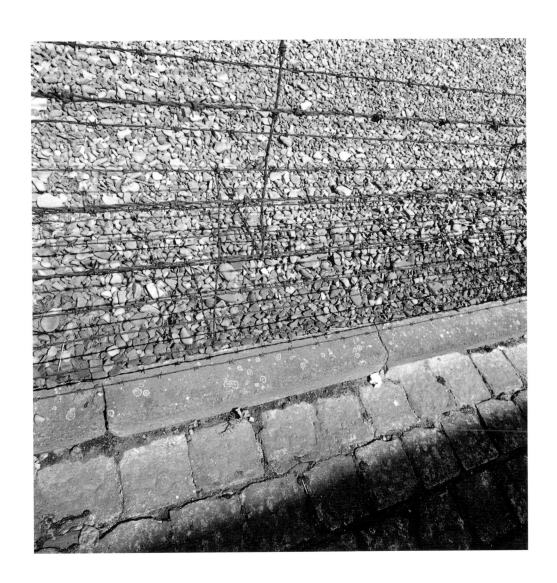

AUSCHWITZ, 1994

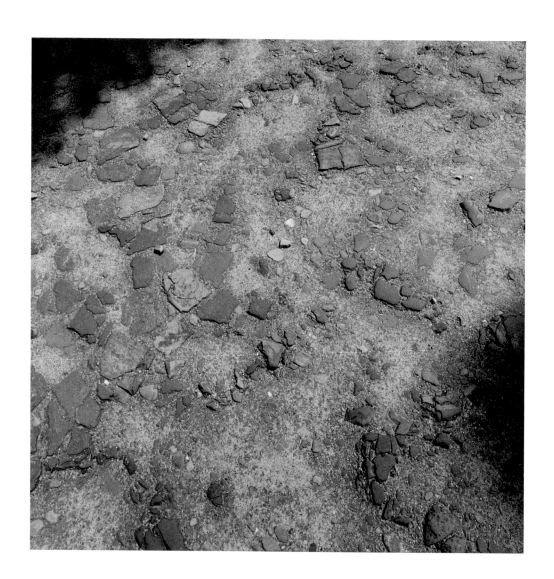

AUSCHWITZ, 1994

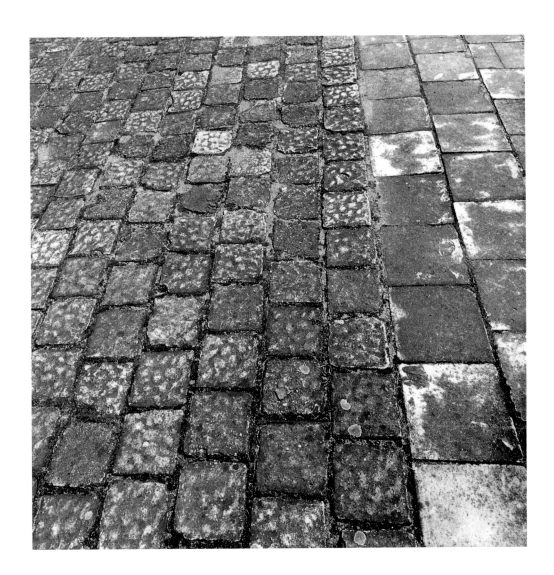

AUSCHWITZ, 1994

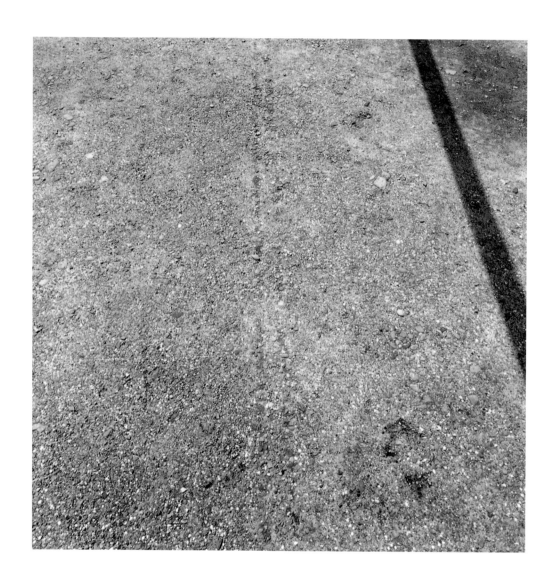

AUSCHWITZ, 1994

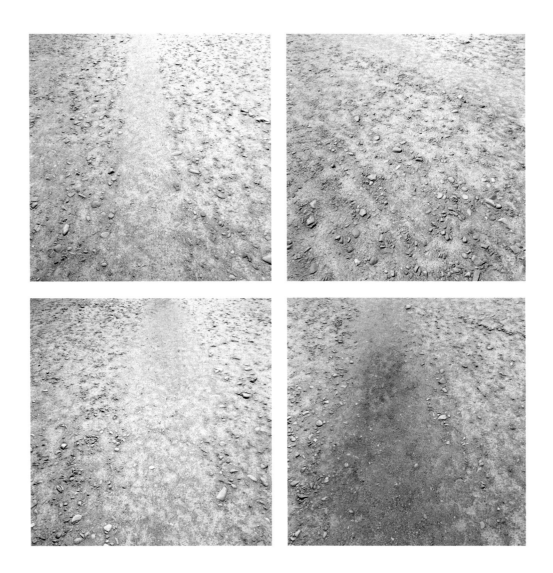

AUSCHWITZ, 1994

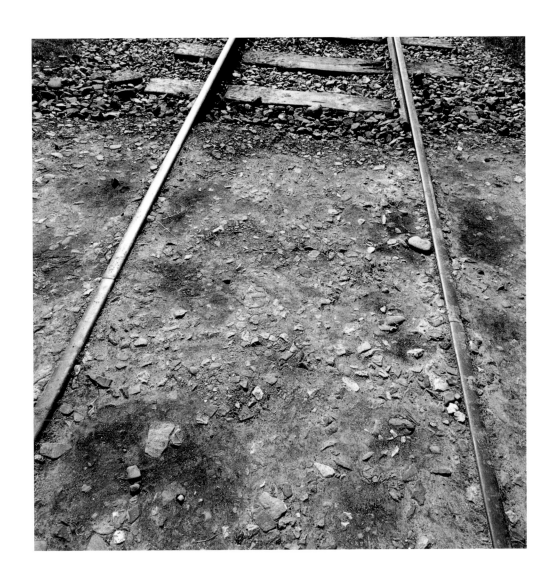

AUSCHWITZ-BIRKENAU, 1994

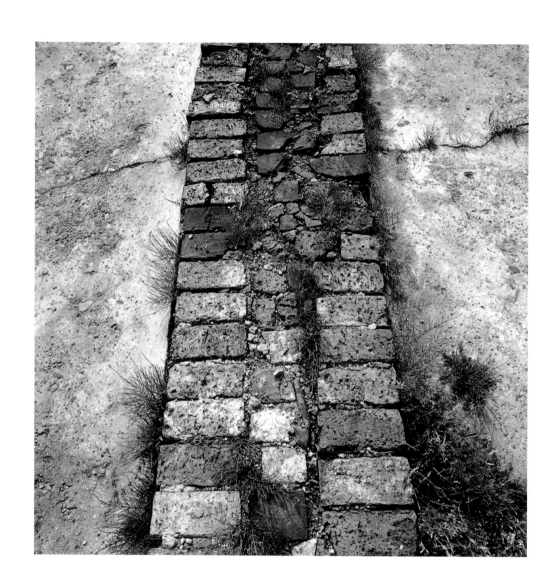

AUSCHWITZ-BIRKENAU, 1994

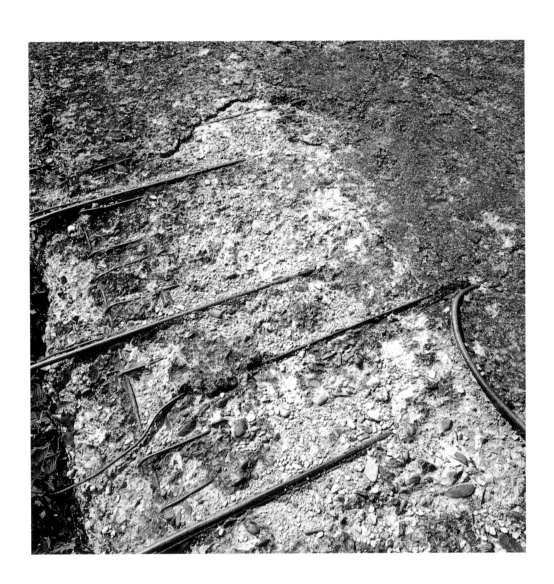

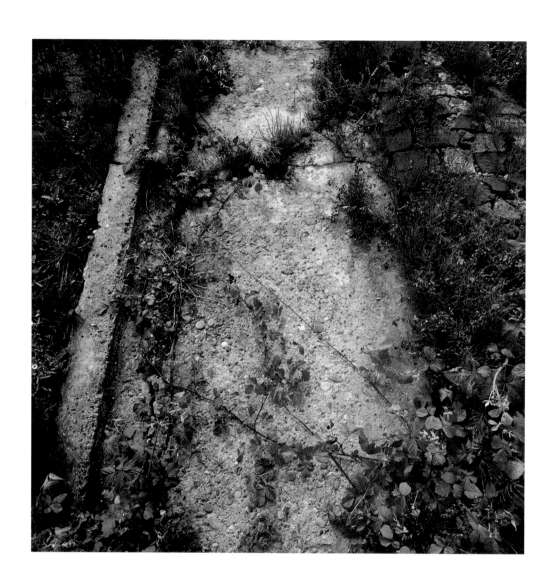

AUSCHWITZ-BIRKENAU, 1994

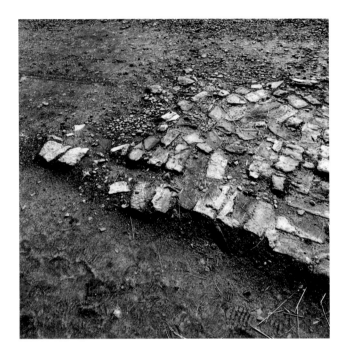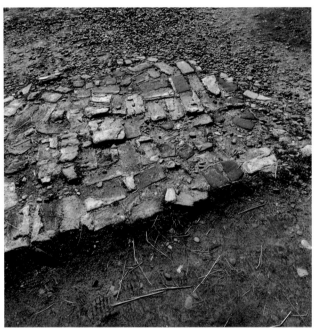

AUSCHWITZ·BIRKENAU, 1994

AUSCHWITZ-BIRKENAU, 1994

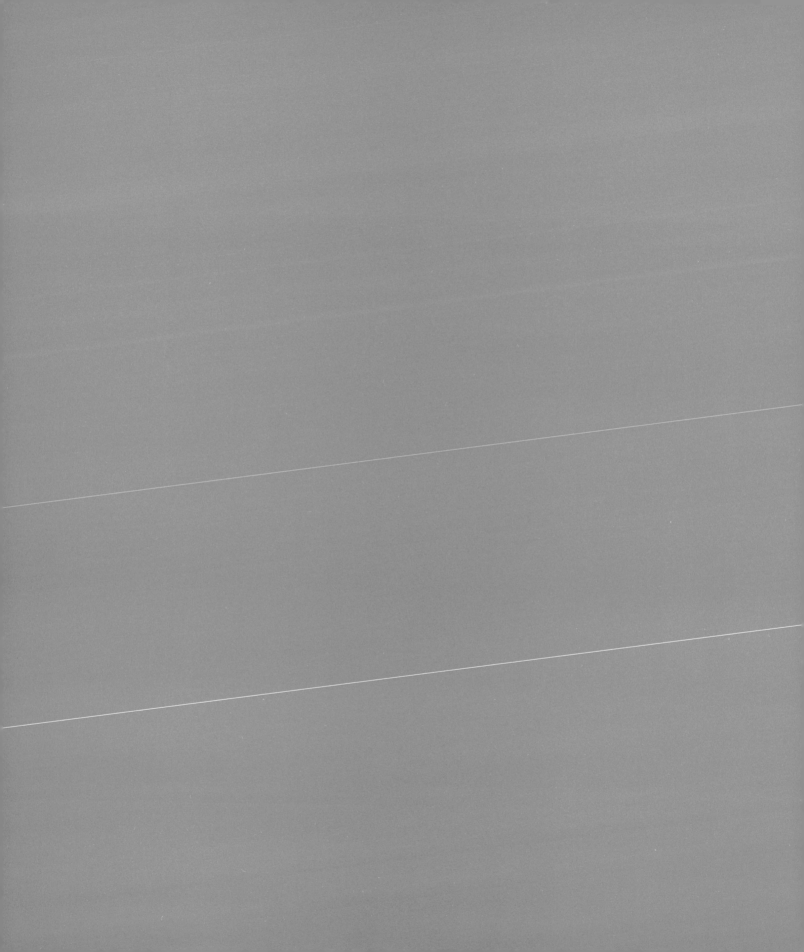

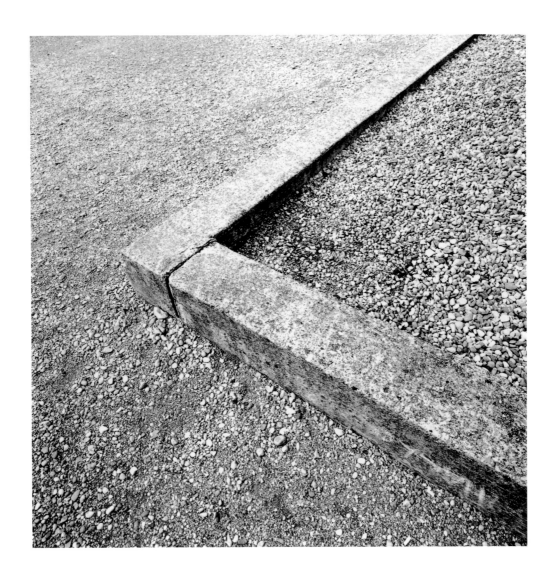

DACHAU, 1992

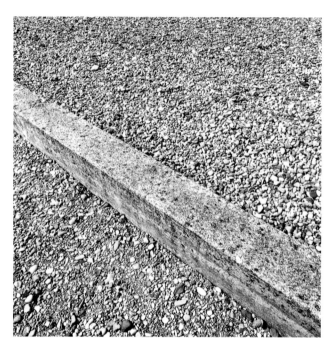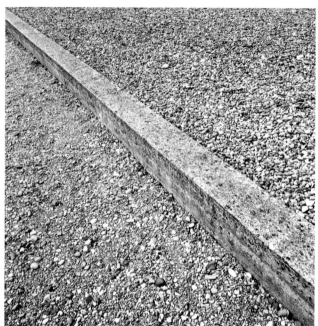

DACHAU, 1992

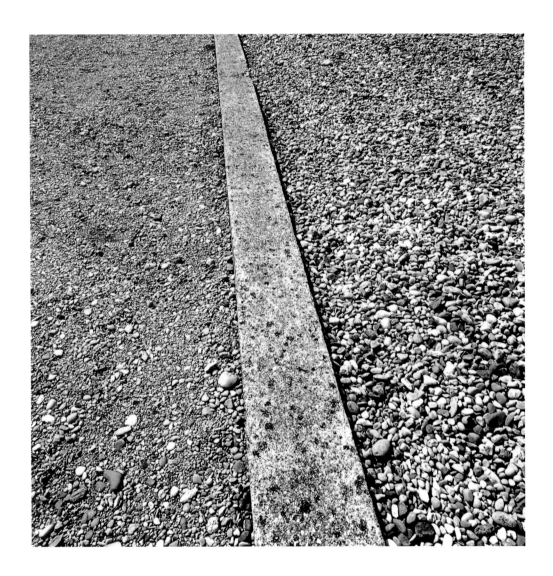

DACHAU, 1992

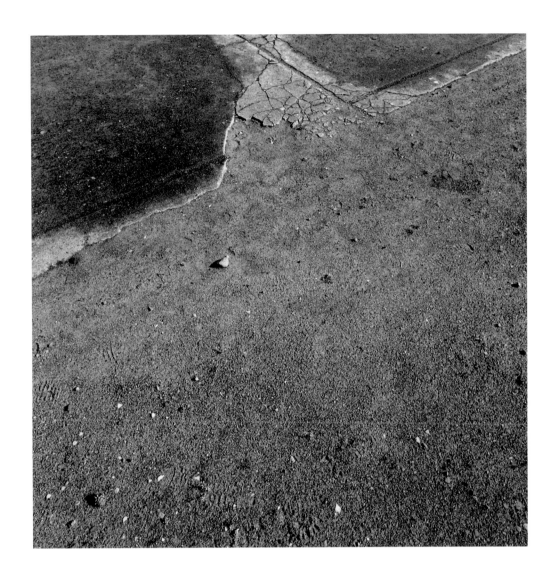

SACHSENHAUSEN, 1994

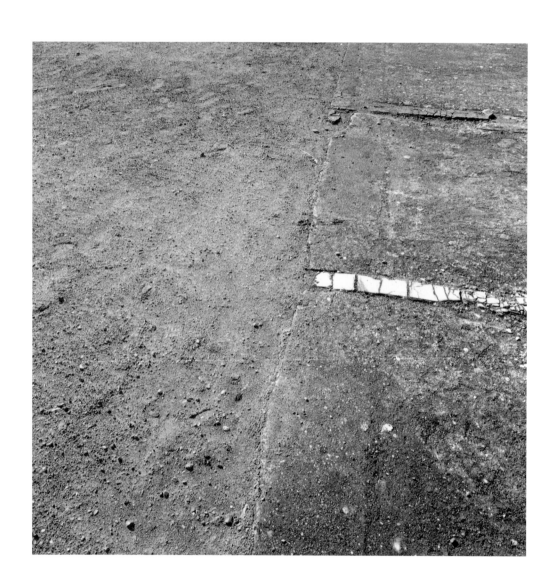

SACHSENHAUSEN, 1994

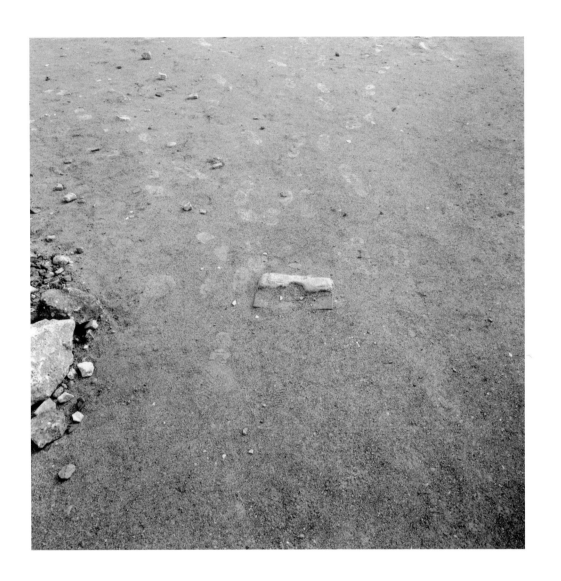

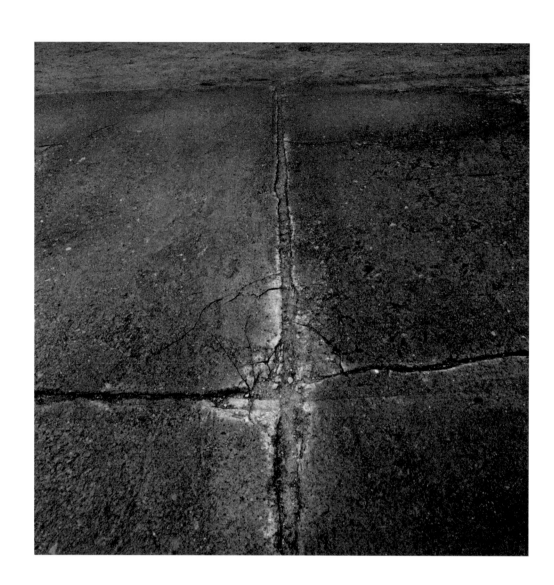

SACHSENHAUSEN, 1994

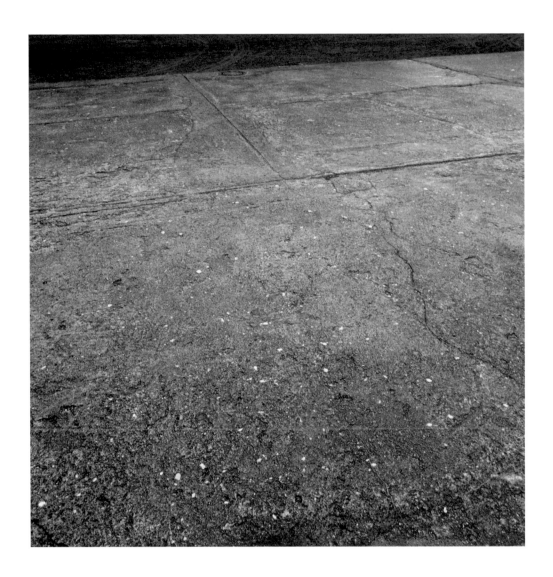

SACHSENHAUSEN, 1994

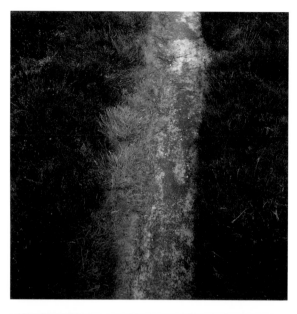

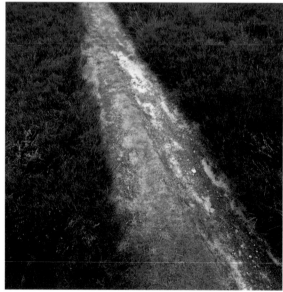

BERGEN-BELSEN, 1994

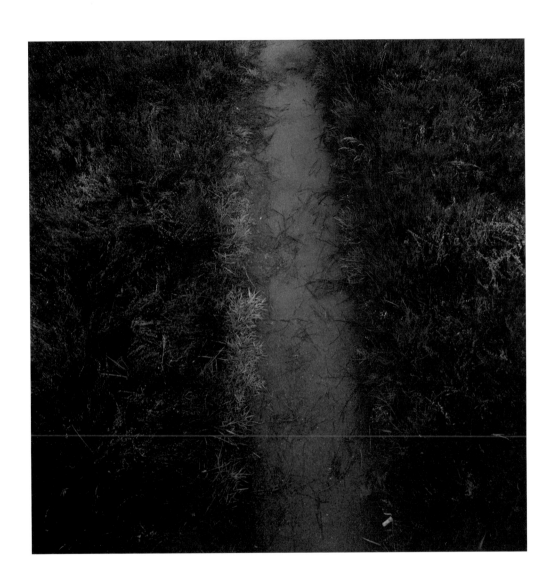

BERGEN-BELSEN, 1994

$\left[\dfrac{58}{59}\right]$

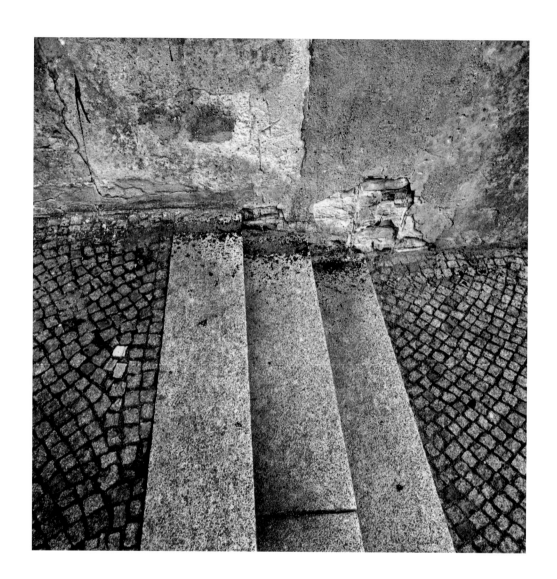

RAVENSBRÜCK, 1994

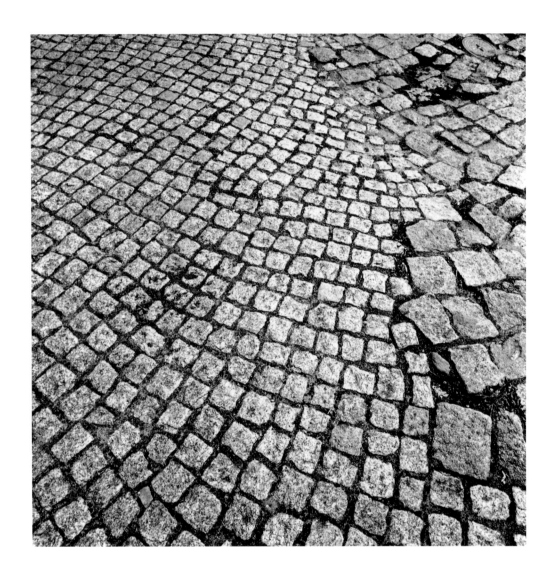

RAVENSBRÜCK, 1994

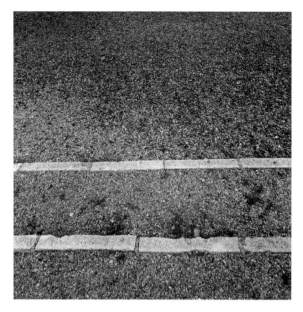

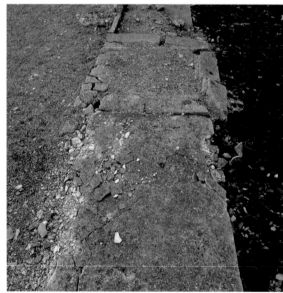

BUCHENWALD, 1994

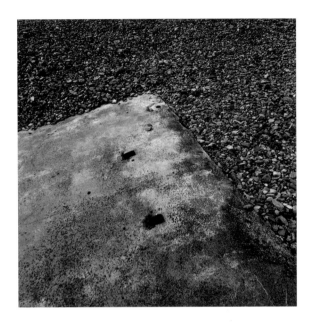

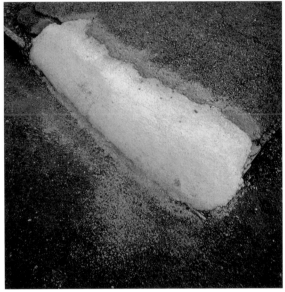

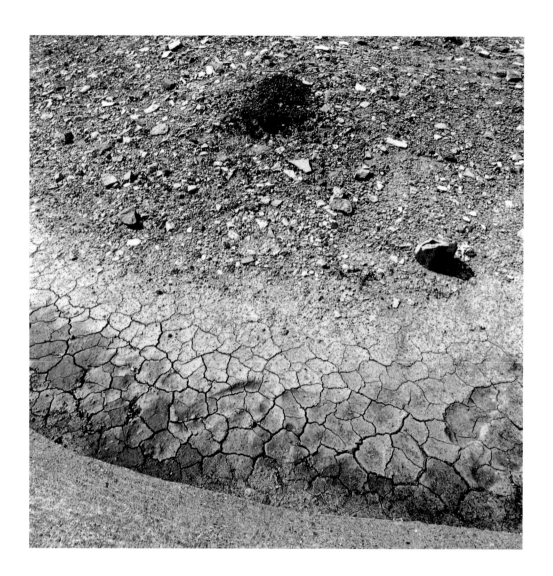

BUCHENWALD, 1994

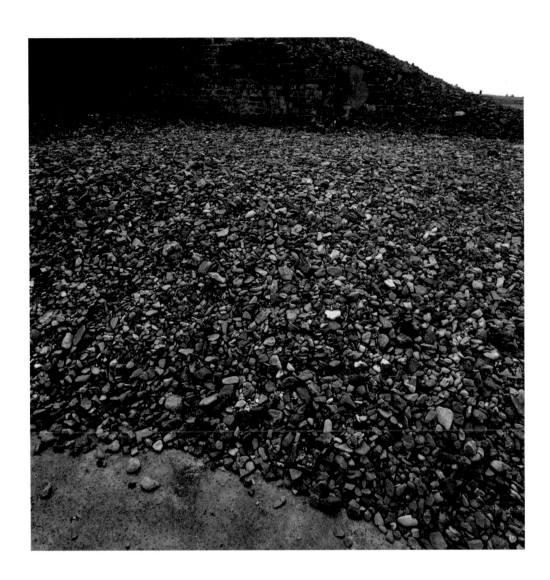

BUCHENWALD, 1994

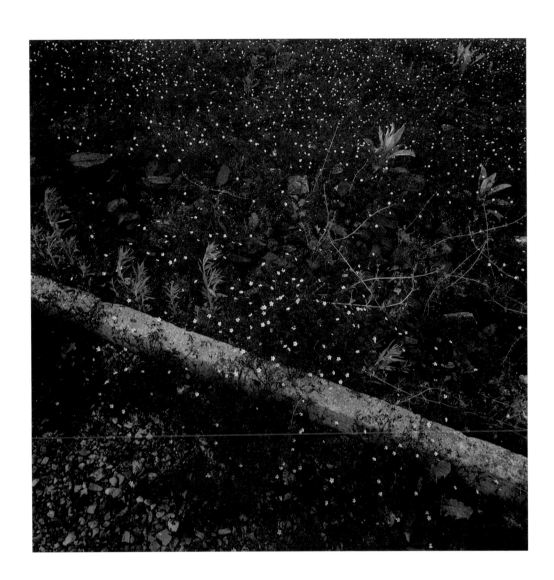

BUCHENWALD, 1994

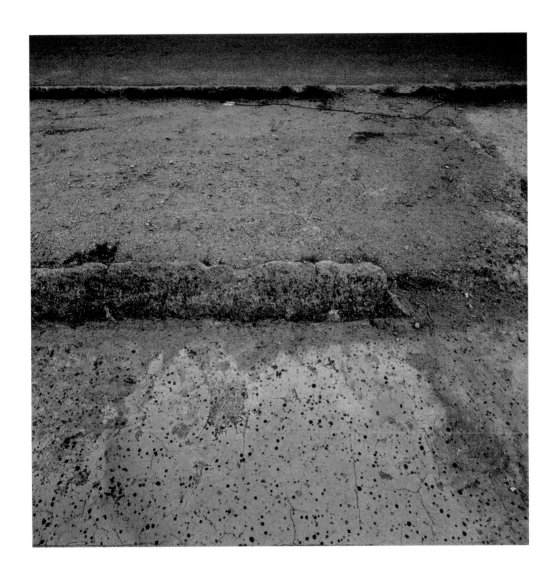

BERLIN, 1994

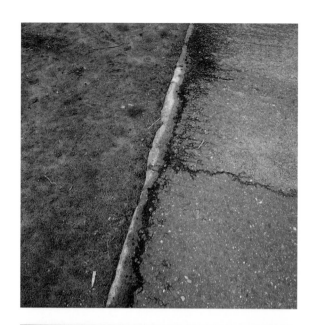

BERLIN, 1992

BERLIN, 1992

BERLIN, 1992

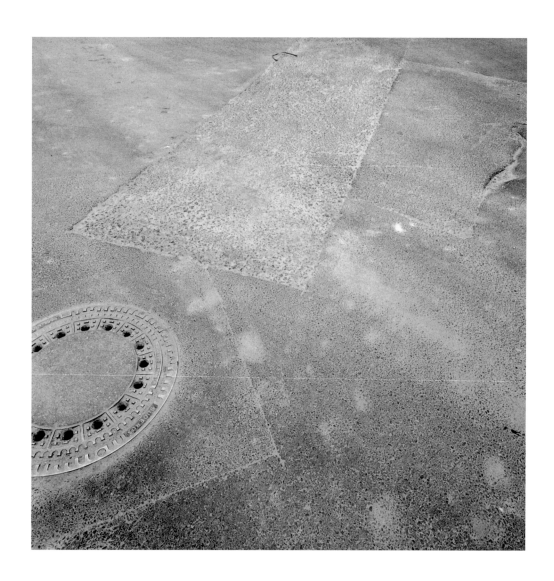

BERLIN, 1994

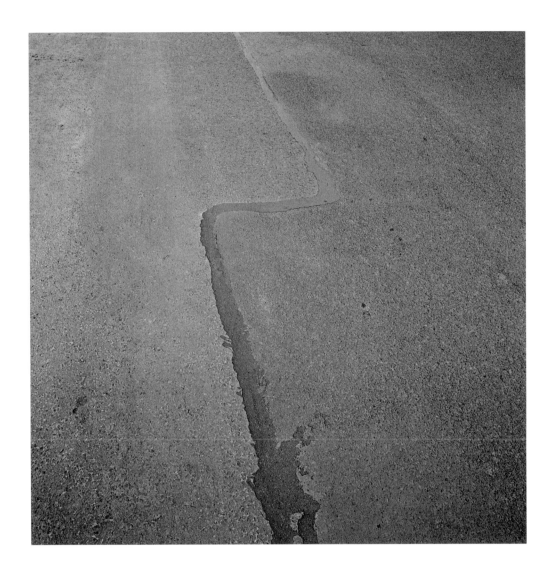

BERLIN, 1994

$\left[\dfrac{74}{75} \right]$

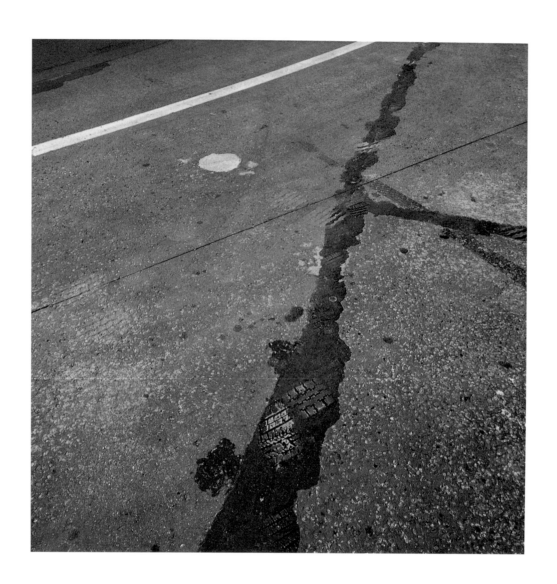

BERLIN, 1996

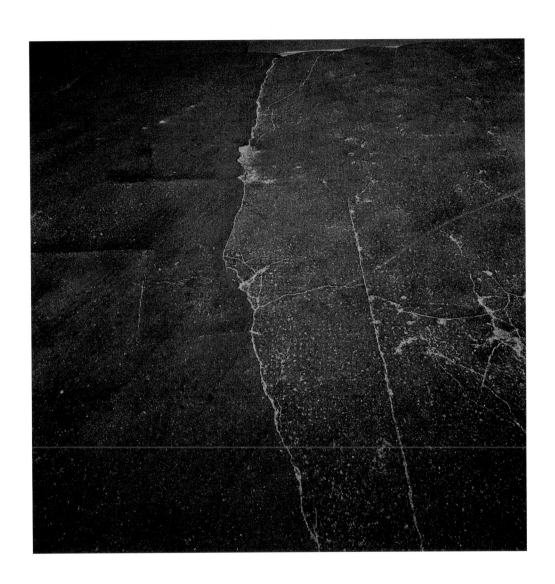

BERLIN, 1994

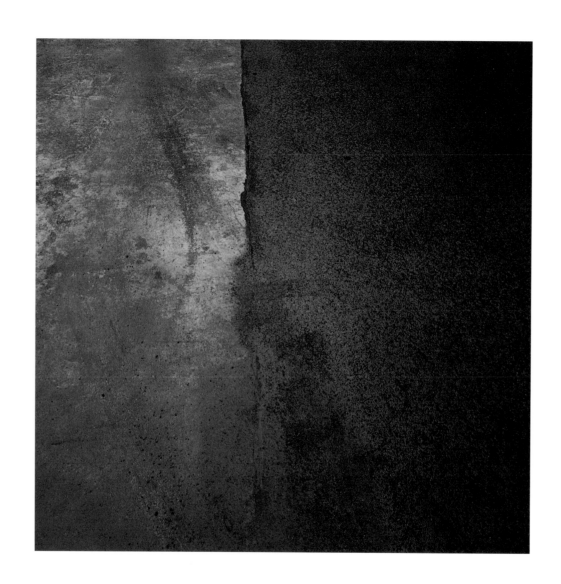

BERLIN, 1994

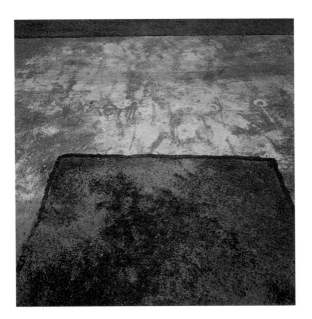

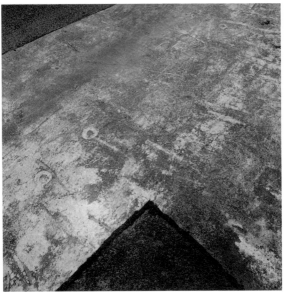

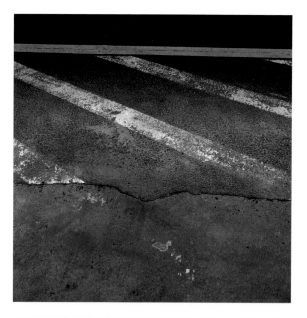

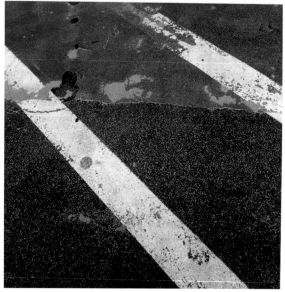

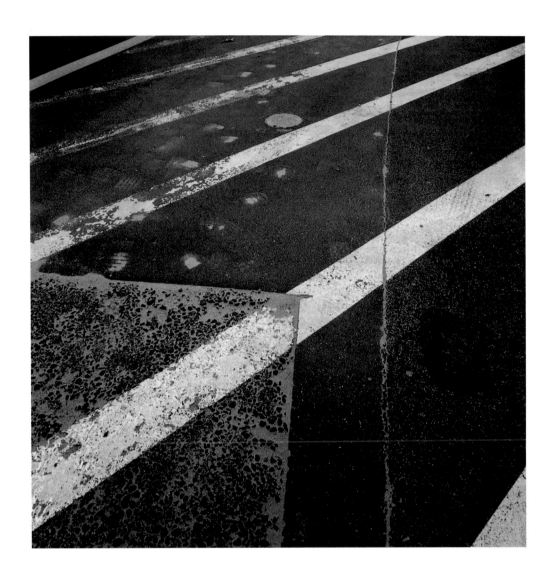

BERLIN, 1996

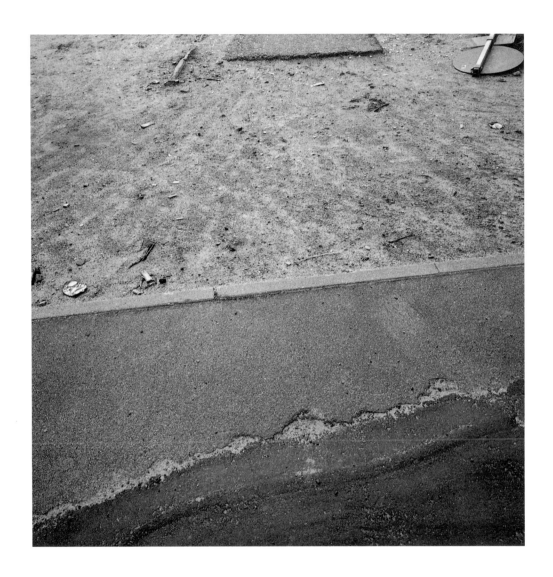

BERLIN, 1996

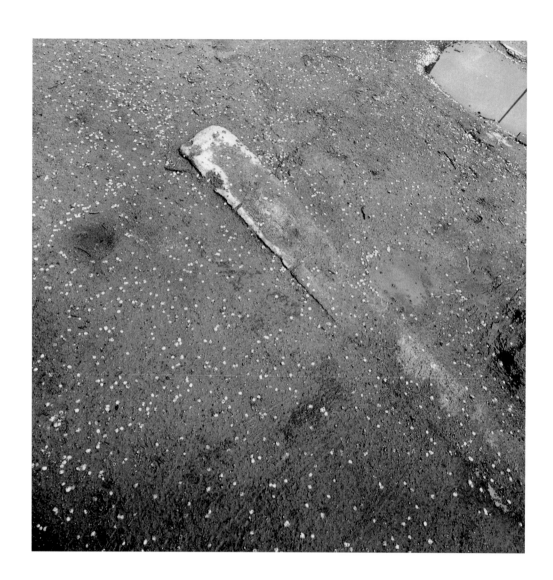

BERLIN, 1996

BERLIN, 1996

BERLIN, 1994

BERLIN, 1996

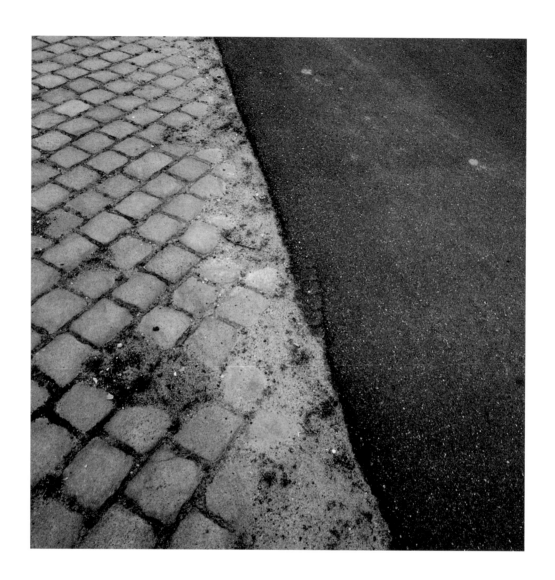

BERLIN, 1994

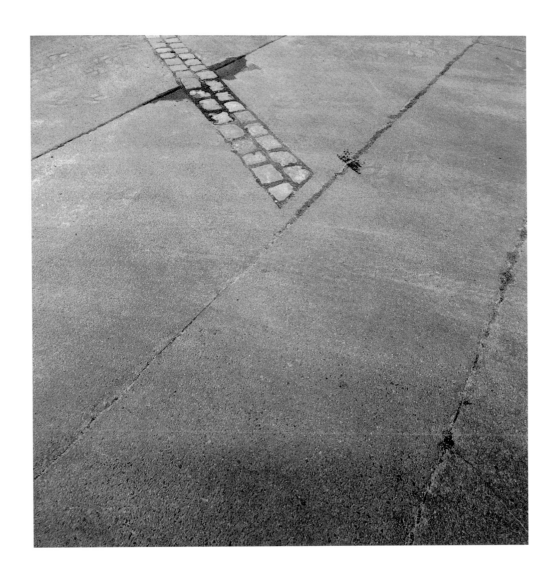

BERLIN, 1996

BERLIN, 1996

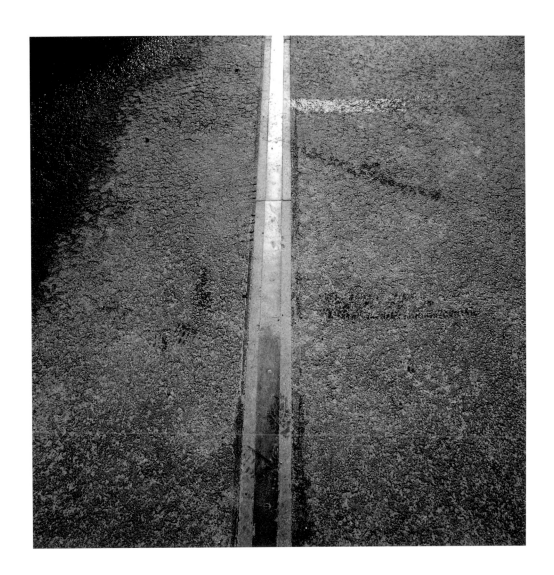

BERLIN. 1996

phantoms

Who might have thought that the battlefields of World War I and the death camps at the center of the Nazi genocide project are under the threat of oblivion, of being forgotten? They are the most commemorated, monumentalized, and archived disaster sites of the twentieth century. But we gaze at Alan Cohen's photographs with their titles as if we, the viewers, were the last witness to the final scene of the disappearance from sight and memory of these catastrophic sites, as if Cohen's camera had captured the last glimpse of a collective trauma sliding into oblivion. These photographs offer themselves as the vicarious bearers of these traumatic traces; and as viewers, merely by looking at them, we might consider ourselves to be memory-bearers.

Is trauma so vicariously contagious? The titles are toponyms: the "Somme," "Verdun," "Dachau," "Bergen-Belsen, "Auschwitz," "Auschwitz-Birkenau," and so on. They have as their photographic referents minute square sections, photographic tiles that without the toponymic descriptor would be unrecognizable (with few exceptions) as sites of historical calamity. Here is rolling serpentine countryside and curvilinear mounds, there is the vertical of a well-trodden path; like a flag of textures, the rough between the smooth, a textured version of an abstract expressionist painting (Clyfford Still's *November 1953* comes to mind). In one group of photographs (page 39) I discern a path, calling to mind a dense

palimpsest of footsteps. How to date a path? What is more immemorial than a path as a sign-bearer or carrier of human presence?

Who, without the help of the toponym-title, would conjure up tens of thousands of victims force-marched to their deaths along this path, would recognize that these photographic records, *tiles* in view of their formal composition, *capsules* in view of the evidence they hold, are like atolls in an ocean of mass murder? By what scale do we measure that tile and locate its exact place in the humanly engineered void of the death camp? What lens? At what distance was the apparatus set up to the object? Nor do I think first of the sensual mounds (page 17) as being trenches for thousands of men; or that a grassy pool, the visual punctum of another photograph (page 18), might well be a shell crater. Similarly, to take an image from the closing sequence of this book, that the photograph is a stack of surfaces, brick, cement, asphalt, suggesting a street of a venerable European city. Painted broken white lines, the latest addition, pass over an older surface (pages 80-81). Without the legend "Berlin Wall," I might view the broken white lines as rerouting traffic, the result of a local decision in a town planning department. But the conceptual charge of the photographs' legend draws me to read the broken white lines as passing from East to West across the ruin of the Wall—a visual sign of the epochal and momentous, breaking through the ordinary circulation of signs: a consummate photographic witness to history.

The psychoanalyst Nicolas Abraham wrote that "what haunts are not the dead but the gaps left within us by the secrets of others." Alan Cohen's photographs reveal and navigate these gaps. They induce the feeling of the presence of phantoms. The spectator is witness to secrets, no less secret for having been already revealed, documented, commemorated, and archived. Once again Nicolas Abraham: "the phantom which returns to haunt bears witness to the existence of the dead buried within the other."[1]

The Berlin Wall series offers a purchase on and a culmination for Cohen's highly schooled and aesthetically tuned photographic art. His photographs are marked by an approach that arises from abstract expressionist painting and its successor, minimalism. Cohen's approach can be seen at work by considering the lower vertical boundary of the Wall where it once rose from the ground. This contiguity between where the Wall had stood and the ground that is all that remains

1. Nicolas Abraham, Maria Torok, and Nicholas T. Rand, *The Shell and the Kernel* (Chicago: University of Chicago Press, 1994), pp. 171ff.

of the Wall, is the point of entry, the *touché* for Cohen's visual problematics. The Wall has returned to ground; a demolished vertical yields a horizontal as a signifying surface. It signals an absent vertical. Not the Wall but the absence of the Wall is the trace. The subject then, returning to Nicolas Abraham, is not the Wall but the phantom of the Wall. Alan Cohen's postminimalism induces a double phantom, the phantom of the Berlin Wall and the phantom of an abstract expressionism that would constitute the Wall as inscriptional surface (pace Cohen's teacher Aaron Siskind). The sites of calamity are thus visited through an approach that evokes the phantom in its method of emptying. The toponym summons the phantom.

These photographs stake a claim as keepers of the trace, sharing a favored role of contemporary art as custodian-witness. Cohen's photographs might be compared to the studies of Richard Long in, for example, the documenting of his walks, or the work of Christian Boltanski, especially in the earlier series *Lessons of Darkness*. At the same time Cohen's photographs can tellingly be compared with the work of Anselm Kiefer.[2] Kiefer not only fabricates a visual surface as representing historical ground, but in his almost barbaric disregard for the Greenbergean insistence on the canvas as an autonomous zone for visual inscription, he maximizes the inscriptional capacities of the surface to ingest the nightmare of history—artifacts, material detritus, hagiography, allegory, and all. Where Kiefer saturates the surface with discourse, Cohen maintains an almost formal distance with his verbal signifiers, sweeping them clear of the photographic surface. The contents of his images are pristine and still because they are wordless. We are forced to pass from a signifying surface that empties meaning to the visual minimum, to a toponymic frame that imbues the whole to the maximum of verbal suggestion. The stillness of the images is shattered by language. The intervention of history, for Cohen, is verbal and noisy.

On European Ground is thus a work that communicates between two registers—an aesthetic of visual delineation that pursues visual meaning through the elimination or emptying of all that is deemed visually extraneous, leaving the deposit of a trace, and an ethical calling that witnesses and archives the visual residue as evidential traces of calamity.

2. Two recent papers of mine address the presumption of the witness in the visual arts: "Witness in the Errings of Contemporary Art" in Paul Duro, ed., *The Rhetoric of the Frame: Essays on the Boundaries of the Artwork* (Cambridge: Cambridge University Press, 1996), pp. 178–202; and "Picture and Witness at the Site of the Wilderness," *Critical Inquiry* 26, no. 2 (winter 2000): 224–47.

Was it not noticeable at the end of the war that men returned from the battlefield grown silent—not richer, but poorer in communicable experience? WALTER BENJAMIN, "THE STORYTELLER" | In the journey Alan Cohen took to make these photographs, he did not, so it seems, commence chronologically at the beginning of the twentieth century with the battlefields of the Western Front in World War I and end with the disappearance of the Berlin Wall at the century's close, with the death camps as the historical and calamitous centerpiece. Indeed the photographer came to the battlefields of the Western Front as the initiating site for his published photographic record only toward the journey's end. Yet he needed that disaster site to inaugurate his visual inquiry. Perhaps he too followed Walter Benjamin in reaching back to World War I. For Benjamin, the war on the Western Front was a death blow to the capacity to narrate. It was the catastrophe that was to be the testing ground for the catastrophes that were to follow. World War I was the great fault line within modernism itself, marking not just a before and an after, but also the modalities of modernism that were to follow from the war. One feature links many modernist projects together, namely the fabrication of an autonomous domain of art that would take into itself, render into form, the very communicative crisis of modernity. From the moment of modernism forward, what is capable of being transmitted are the vestiges of the damage to human experience itself. The shattering of a communicative capacity launches the pursuit of artistic form. In this sense Alan Cohen's photographic tiles are themselves sublimely modernist fragments. They are poised on a knife edge between a faltering *volonté de memoire* and a voracious historiographical compulsion to accumulate and store documents as a substitute for living memory. The photographs in *On European Ground* are intractably of their present and thus artifacts to and tokens of an ever-receding, indiscernible, and remote past.

Alan Cohen's photographs place difficult demands on the visual reader. We are allowed to be witnesses to these photographic traces only by reflecting upon the paradox of photographs offering traces by subliming them, and upon our own insufficiency, if not our very ineligibility, to be witnesses to the overwhelming conditions of modernity. *On European Ground* is a sublime, eerie, and rare *memento mori* of the twentieth century, especially for an interpretive community still sifting for sense amid the collective ruins we have inherited.

roberta smith and alan cohen

R S Your family moved to North Carolina from Philadelphia in 1957 when you were thirteen.

A C Yes. We moved just as the old world of North Carolina and the Jim Crow South were under momentous pressure to change. The first thing I remember confronting is the openness of the place—the sweetness of the drawl, the welcoming words—and then the signs on the restroom doors and drinking fountains that said "White" and "Colored"—Colored Men, Colored Women, White Men, White Women.

R S That must have been a shock.

A C It was. The overt rage and obsessive public fear were new to me. I didn't fully comprehend it until I was in high school and a family friend whose business was near the black high school encouraged me to go there and just take a look. They had a partial roof on their building, old books, old desks, old everything, while the white high school that I attended had everything that the town could offer. It was distressing as a kid to understand that, without understanding, in a way, anything else. It made me very uncomfortable. I knew it was wrong and so, one day, on impulse, I went into a Colored Men's restroom.

R S On purpose?

A C Yes. One day, in a store where my mother worked, I went into the nearest

available bathroom. The older men in that bathroom asked and pleaded with me to leave; they were afraid that something might happen to them because I was there. I left but without understanding why. I thought they would know that I was an ally.

R S But they couldn't be joined at that point.

A C That's right. I thought they would welcome me in joining them but that wasn't possible at that moment—it was my idea, not theirs.

R S In a way we're already talking about your work. You're describing living in a place and in an era that was a kind of battleground. There were zones and territories, and visible and invisible boundaries, and people were divided by tradition and suffering and governed by a very old history that was in many ways gone, but not at all forgotten.

A C I never made that connection before but I think that you're quite right.

R S You also said that at an early age being a scientist became a goal. Did it also become a factor in a certain kind of behavior?

A C I'm sure it did—intentions drive behavior or, at least, modulate it. I always knew I was going to be a scientist. I had been in elementary school when the Russians launched Sputnik and the teachers told every student with a facility for mathematics—arithmetic really—that we should become engineers and scientists. That belief provided certainty and direction for me.

Much later, while a number of college friends that I knew wanted to write or wanted to make films, I knew I could never do that. I never thought I had the capacity to write anything, or do anything creative or inventive, but I always read. I wasn't focused in any way. I'm not even sure I knew my own tastes. I just knew that engineering wasn't enough because there was not any way to relate it to all this extraordinary stuff that was going on around me.

The South in the sixties was tumultuous. I lived near the Greensboro lunch counter sit-ins and went there on the second day of mass demonstrations. I was witness to these heroic efforts to overthrow segregation. Also, the Vietnam War was fearful—it infected everything and every life in its time. My life was split by the forces of that decade. So, as an undergraduate in a nuclear engineering program, I could go from a class with my academic advisor Albert Carnesale, who became a technical advisor to the SALT I negotiations and is now chancellor of UCLA,

to a class with Allard Lowenstein, who eventually won election to Congress from New York. So, on any particular day, I could be reading James Baldwin and about neutron slowing-down theory; I could do both, and enjoy both immensely. But I never knew how to connect them, and was resigned to the fact that these interests would never be linked.

R S But it seems that for a time you found a certain amount of creativity in science, at least when you first began to work at Argonne National Laboratory, near Chicago.

A C Yes. Argonne, then, was a special world. It was very creative, very open, populated by some terrific minds. It was, for a time, a utopian setting that was gracious, wonderful, and supportive. Learning, invention, and work were the same thing. But the Vietnam War hammered the budget, skewing and transforming my job at the laboratory. When I was hired in 1966—I ended up doing research in high-temperature thermodynamics—the laboratory supported and valued far-reaching scientific inquiry. Argonne would support visionary work if that work had the merest fragrance of reality. As its budget declined, the laboratory became more reality based and rule-conscious and that atmosphere made it less appealing to me. I didn't like the new culture and I didn't want to be there any more.

R S So you left.

A C I thought about leaving; I struggled with the issues of where to go and what to do.

R S When did photography come in? When and why did you pick up a camera?

A C In 1967, while at Argonne, I met a woman who lived in Chicago for the summer; she was going back to college, and she asked me, in her last week, if I would take a picture of her. And I said sure! Yes! Before she asked it had never occurred to me to do that; I had no experience in marking events through pictures. I bought a camera and took her picture. I took two pictures. And then I gradually took other pictures. And it became really interesting for reasons I didn't fully understand. It was very satisfying to be able to communicate with people directly with information that I didn't have to explain. I just showed them something. It was so unlike my work at Argonne where, as the work became more and more stratified, I had fewer and fewer people to share it with. Photography was so different—it was a completely different way to talk to both colleagues and strangers. I felt that I was in the same orbit with friends who were doing creative things.

R S Did you think of it as a hobby?

AC I never thought about it like that. It was something that I enjoyed and I thought I should be better at it. I don't know quite how things moved along. I really can't remember very much about that because it's so—

RS Prehistoric?

AC Yes, exactly.

RS You said you had exposed fourteen rolls of film when you met Aaron Siskind in 1968. So in other words you kept taking pictures while working at Argonne.

AC Right. I had a camera for maybe a year. And I just went about photographing in a very methodical way—I tried to figure out what and how to photograph. I didn't have an agenda and I was without a specific project. I would only take the camera out when I decided to make pictures, rather than have it with me and spot something. I never took vacation pictures, family pictures; I never took site pictures. I've never worked like that.

RS So you've only worked with a certain kind of intent. What did that intent focus on in those first rolls of film?

AC Oh, a style more than a subject—a graphic quality, an organized, very formal picture, organized lines, orderly space, clean.

RS And you were just walking around the city?

AC I would go to places that had some component of old architecture and new architecture—contrasts in time, style. One other thing—an event—I photographed early on was a rally for Eugene McCarthy, who was running for president at the time. His plane landed at Midway Airport. I stood atop a platform outside the terminal and photographed the crowd looking at him. I was interested in looking down at the group and seeing this sea of people. I was interested in the mass.

RS So you took a picture at a McCarthy rally that didn't have McCarthy in it.

AC That's right. I felt then, just as I feel now, that it's very hard to describe an event through a photograph. I don't know how to be that honestly reductive—and didn't then either.

RS You're sort of the opposite end of the spectrum from, say, Cartier-Bresson and the decisive moment.

AC Yes. I would have a decisive four years. As a scientist-artist, it is difficult for me to distill complex things into something with only a few elements. At the same time, I really welcome that kind of work from others. I thought Cartier-Bresson and

some fashion photographers were wonderful; I know their work helped me to continue constructing pictures.

R S You couldn't think, oh, there went a decisive moment and I missed it?

A C I never thought like that. I am educated in twentieth-century science and I think that gave me an intrinsically different approach to art in several ways. The evidence and theories of science are cumulative. Science doesn't depose; it isn't about revolution. It is about taking known things and hollowing out the old words and filling them with new meanings and placing a different emphasis on the same words once strung together in a different pattern. Scientists would not purge, for example, Newton from his deserved place in the history of science because our contemporary concepts go far beyond his. We reposition and recalibrate the outer boundaries of early ideas to fit the more complex truths of contemporary thinking. But I never gave myself permission—in science or art—and never felt it necessary to push my elders aside.

R S How did you go from working at Argonne Laboratory to studying with Siskind?

A C A friend, studying film at the Institute of Design, saw an announcement for a photo graduate seminar to be chaired by Siskind and recommended that I go. It was a revelation. I heard, for the first time, how pictures could be discussed and how they could be *made*. And I experienced Aaron's mastery as a teacher, the way his combination of intellectual rigor and his earthy manner repeatedly rescued his students from confusion. At the end of the class, I told Siskind that I wanted to study in his program. He told me what to do and I did it.

Siskind, at first, gave me reasons—his reasons—for making art when I had no clearly articulated reasons of my own. He offered his way of thinking about photographing while encouraging my exploration of experimental photographic process. In the 1960s, process seemed to be the way to visual relevance. Under Aaron, my photographic education was a marriage of Bauhaus experimentation and Abstract Expressionist gestalt. I came to understand that he was helping me find subject matter—ideas—that would make the photographs meaningful.

R S It's interesting that Siskind identified with the Abstract Expressionists while doing something quite different. Unlike any of them, he used a camera. He was, in effect, taking completely objectified pictures of the world, yet he felt that their approach still applied to him.

A C Yes, because it was a method that absolutely internalized the objective world. Siskind held that the only way he knew the world was in this Abstract Expressionist way of internalization. Once internalized, the facts of choice could be presented through the individual's expressive sensibility.

R S So that when he was working, when he went out with his camera, he would be looking for things to which he had a certain intensity of response. He would seek out a kind of preexisting expressive abstraction.

A C Yes, but abstraction driven by the power of his early life. He did documentary work throughout the 1930s—he was keenly and lyrically political—and that shaped him as an artist. The gestural marking and graffiti that he found on walls and then photographed were aesthetic, but they were also often intended as political or at least social messages by the people who had originally put them there.

As a student, I may have misunderstood the potency of social documentary imagery for Siskind and for his students. Yet his extreme selectivity, his careful framing and editing of fact was right up my alley. Scientists are aware of the complexity of the world and are educated to live with the unknowable. Scientists and artists are comfortable with generalizations and assumptions. We make assumptions about what aspects of reality we want to use and to discard, and then we somehow just state them. So if it was decided, as could be done in certain cases, well, today, no gravity, then you drop gravity from your calculations. You could do that and see where that got you. So in photography I felt that I could tinker with the real world even though I was really tied to it. Hence, I had this conflict: I was attracted to Aaron's ability to just block out huge chunks of reality, but at the other level there were other artists who were really looking at the world in a bigger, more inclusive way who were very interesting to me.

R S For example?

A C Oh, I remember works by Joseph Beuys, Leon Golub, Michael Heizer, Robert Smithson, Philip Pearlstein. They were all tampering with the gravity of art—with big art issues—by redetermining how to work with reality. And the other thing that helped me right at the same time was—of all fantasies—the landing on the moon. I experienced it in a sense as an aesthetic exercise: we were going there to be there. The value of the journey was the journey. We didn't stay there long enough to do anything meaningful. The process was the reality, the hard-core nuts

and bolts of getting there and then to dream of standing there—at least for those of us left back on Earth. This was a great mix. It hit every button for me. It was utterly fantastic. I couldn't sleep on the days of the moon landings.

RS Now I see why Sander Gilman introduces his essay about you with the moon landing. It must have been a very important counterbalance to the internalization that Siskind exemplified. I was interested in his *New York Times* obituary, which quoted something he'd written in 1950: "First, and emphatically, I accept the flat plane of the picture surface as the primary frame of reference of the picture." He was inclined to see it as an object, as a completely autonomous two-dimensional thing. So that whatever he did with that object—

AC However you got to the object—

RS However you got to the object—

AC Was fine was him.

RS Whatever you did to it in the darkroom—

AC Was great. With all the experimental work going on in the sixties, so much of it was process—it was like going to the moon—it was like Rauschenberg's erasure of a de Kooning drawing. Siskind was simultaneously encouraging the veneration and erasure of his generation through experimental process.

RS The late sixties and early seventies were a very interesting point to come into photography. Photography was basically being absorbed into the art world. Younger artists, many of them untrained in photography and unfamiliar with its aesthetic tradition, were using the medium in all kinds of new ways. Was he tolerant of Smithson—you mentioned him—for whom the camera was just a tool?

AC He was tolerant of work like that. He couldn't do it but he could find a way to talk about it and embrace it. Still, I knew about Smithson's work mostly through the art journals—in the articles and ads—and I thought: wow, that's nice and enticingly excessive but it was not an aesthetic that I was getting as a student.

RS So, what kinds of pictures were you making in Siskind's, Arthur Siegel's, and Garry Winogrand's classes?

AC Formalist pictures made across extended time—mostly one-second-exposures. Two months after I began graduate school, Siskind asked me if I would like to join him in photographing Paul Sills' theatrical troupe in performance. With live rock music, they created a narrative-dance fusion done in the round very close to

the audience. I had no idea what I would see or what I would do; I went because Aaron invited me. I went with a very, very slow film I had been using to record architectural details in bright sun—stationary objects. So I had the wrong film for a theatrical production where . . .

R S . . . no one would be stationary!

A C That's right—nothing was stable. But I brought a tripod. So, with the camera on the tripod, and the lens wide open and the shutter set at the slowest controlled time that I could work with—one second—I made pictures. I photographed the performance with its erratic, shifting light at one second or I made a multiple exposures of one second each on the same negative. Photographing became freewheeling, intuitive, a gamble and as improvisational as the performance itself. I had nothing to lose but film. I would sometimes look over at Aaron to learn some of his photographic secrets and I would see him purposefully at work.

R S So he was loading and unloading film and clicking away.

A C It seemed so purposeful and I thought, I'm totally off the mark. I'm going to be crushed by his vision and his ability to deal with this visual disarray. He asked me to bring that work to class. So I processed it, brought it to class, and he loved it. And, actually, so did I. I was making pictures that I couldn't see. I loved the idea of being detached from a knowable reality. It was crucial for me that I not know with certainty, at the moment the shutter closed, what was happening on the film. I had to be surprised by my own work—by its translation of what I saw into what I could not have imagined. It was so exciting to me that all my work for more than a decade and a half—beginning in 1969—was made with long exposures.

R S From the description it sounds as if you were making Abstract Expressionist photographs.

A C At some level I was.

R S That Siskind would have embraced as related to his own, and yet going, getting there in a different way.

A C He did and they were. I think that I also knew they were going in a different direction.

R S It sounds like the decision-making process was completely skewed.

A C Yes, there's a level of abandonment that separated it from science, from Siskind's working methods, and also from anything prosaic, which was important to me at

that moment. Contrary to my initial connection to photography, at that point, I found that I didn't want images that could be understood, actually. I think I had become uncomfortable with my earliest pictures and considered all my work unsuccessful if it could be easily understood. I liked the fact that my dance-performance photographs were these random, arbitrary documents and also a little mysterious. It seemed similar to what attracted me to the images of Smithson, Michael Heizer, and Walter DeMaria—they also made documents that were by-products of another artwork. The documentation of their earthworks yielded, I thought, pure photographs. I also liked the fact that they embraced earth as a surface—as a material—a material to work on.

R S You mean that they didn't adhere to the view of nature as inviolate and untrammeled, like Ansel Adams or Edward Weston?

A C I was struggling against that, and working with the sense of sixties invention and working with the sense of Abstract Expressionist internalization—all those impulses—and then I was confronted with the clarity, the absolute clarity and the utter simplicity of what these earth artists were doing.

R S Basically, they were just trying to figure out how to make what they were doing in the desert known to people elsewhere. The answer was obvious: use the camera.

A C It was great for me and I think it was also great for the medium. It took photography out of a small alcove in an inconsequential wing of a very large building and brought it into a fuller critical light. I was ecstatic about that.

R S They changed photographic history. Their work has now been absorbed into a history of photography that has been expanded on all fronts itself. Now you have a larger photographic past and a larger present, too, with a very wide spectrum of artists using the camera, working all over the aesthetic map.

A C A lot of the Europeans artists—from Beuys, Rainer and the Bechers forward—put film in the camera without undergoing catharsis to make a picture. They demonstrated that a picture could come out of a blankness; that a meaningful picture could come out of the conjunction of numerous, different things, many of them unknowable to the maker.

R S Or the viewer. In that vein, I want to ask about your early pictures with mirrors in them: are they multiple exposures? I couldn't tell—they're very confusing, and I don't quite know how they were made.

AC They are enigmatic yet very precise pictures. I was attempting to create some of the confusion of the extended exposure times—but without the extended exposure times. Using a mirror allowed me to create layers—density—in the image by reflection and refraction. I could ignore time and thus consider other issues within the picture. I could build a picture and I could see it. And the images became more real—more detailed—than the images I had built with time. Yet their indecipherability was also important to me.

RS There seems to me to be a tremendous leap from the quasi-abstract photographs using mirrors to the photographs in this book. There must have been some kind of lack, some dissatisfaction that you experienced in a very deep way.

AC There were a few things, but prime among them were questions from my wife, Susan. She's a psychotherapist who proceeds according to experience. Before we met, I did believe that one could know the world through reading, through appropriation. I thought that you could cannibalize the experiences of others; that the travelogue was an altogether adequate substitute for travel. But Susan loves to travel, loves to look, and always wants to take the physical measure of places and events. She believes firmly in going to sites that I thought could be imagined.

RS So how did this get you to Germany?

AC German art of the eighties seemed to me to be really, really potent. I knew it was central in my thinking about art and I knew that I wasn't doing things of equal depth. Susan said, if you think they're doing good things, let's go see. Let's go there and look around. So I made some appointments to do things and see people—curators, dealers and artists—I knew. We had a full agenda of cities, friends, events, institutions and historic sites. But the central thing came from Susan. When we were in Munich, she said let's go to Dachau. She said we can't be here without going there. I had no inkling of the centrality and profundity of that simple suggestion for me. I wouldn't have gone on my own.

RS Is your wife Jewish?

AC No, her roots are English and Irish and Protestant. Once we were there—this is so difficult to convey because the experience was such a profound one. Until then I had never been in a place that had experienced such unregulated, systematic, and intentional violence, where the earth had absorbed such pain, where there had been such horror loosed, just within the confines of this place, and I was there

now. It was amazing to me to be there. And being there made me aware of the vast discontinuity of the site. Within the camp walls, more than thirty thousand people had been destroyed, but there was no evidence, nothing, in the present tense, to verify my understanding or feelings. I was in a real place where something unreal had happened and that, to me, was like travel to and being on the moon.

I wanted to do something photographic there. But I didn't want to simply document something—a door, room, or object—that had been restored. What I trusted to be true was the earth. I was reminded that the evidence of our lunar presence also came back to us in the form of photographs and rocks. I decided that my link to Dachau was through the ground. The stone, dirt, and barrack remnants—traces upon the earth—were my links to the camp's history. So I photographed the ground. I realized, and wanted the people looking at my photographs to realize, that we were looking at a real extant place. I wanted the viewer to know that I was photographing in contemporary time rather than historical time or Holocaust time.

You could attach information to the photographs that I made. They couldn't validate the narratives and testimonials, nor could the photographs displace anyone's experience or substitute for an understanding of history, or any of that, but they gave you a place to which you could attach information. And that was compelling to me. The understandings that came from this trip changed me and my work. And it seemed that it brought me back into my own past. These photographs were able to link things that I had not been able to link before.

R S By that do you mean the South?

A C Yes, the South, but, in general, history—I could put real life into the pictures. I have a developed political sense; I am intellectually engaged with social-political issues. I have been teaching, for a long time now, the history of photography and thus the history of art, the history of ideas, of culture.

R S The history of photography in history.

A C That's right. Suddenly I found myself able to relate everything I was thinking to actual places I had been—there's a kind of normalcy in this as well, that I'd actually never stated—an ability to share with others these places and these things that I've seen. They're certainly not tourist pictures, but there is some vestige of that in this work.

RS Well, that echoes what you said about your first attraction to photography, how it got you out of the laboratory and gave you a way to relate to people more. But they also take you back to Siskind in terms of how you conceived of them spatially. In this regard Jonathan Bordo's reference to the photographs in this book as tiles is significant in the way it echoes Siskind's idea of "the flat plane of the picture surface as the primary framing reference" and defines the picture as a totally flat square.

AC An independent object.

RS An independent object that is more objectified than Siskind's, who made his images by walking around taking photographs of finite expanses of vertical surfaces as if they were found paintings. Bordo implies this: that the space in your photographs is an extremely physical, literal space. It's no bigger than the space of the viewer's vision. It's the space of physical sight. And it is also the space between you and the nearest surface, which is usually the surface you're standing on.

AC That's right.

RS There's a similar spatial sense in some of your earlier series. In other words, the formal quality didn't change markedly, it was simply radically intensified by the fact that the ground was so saturated with history and was completely charged.

How did you decide what you would photograph? Did you take a lot of images that you chose not to use? I'm just trying to find out if your process is similar to your earlier process.

AC It is largely the same. I would just go out, I would see it, respond to it, and would think for whatever reason that this, these ingredients worked, and that I could communicate something. Except that with the camp images I knew I could communicate something really potent. I didn't take a great number of pictures. It was not like Cartier-Bresson firing away. Sometimes I took no more than four rolls of film—forty-eight pictures. The exception was Auschwitz-Birkenau, where I was just overwhelmed by the scale of the place.

As much as I had read, nothing prepared me for the dimensions of Auschwitz-Birkenau. I never understood that the Nazis had built a city for the sole purpose of exterminating the inhabitants of that city. Its sheer size changed the number of photographs I made. I made a lot of pictures there to protect myself from ever having to go back. I photographed everything I could address then and did so aware that, in time, perhaps . . .

R S You'll see differently.

A C Yes, and I will respond to and reinterpret the information and structure of the negatives differently.

For example, I became especially obsessed by the train systems there because that's how people got there. So I took a lot of pictures of tracks and rotting wood and ties, but they were just too literal. From my present point of view, they need to be more conceptual, more abstract and removed so that people could bring their own histories to them. Ever since I started showing these photographs I've learned that people approach them as stimulants to their own histories, which was more than I anticipated.

I think that was another thing that Susan taught me. She asked me early on about my work and who, beyond myself, I wanted as an audience. I told her that I could happily work without an audience; that an audience would be nice but was not necessary. "Where do you put this work that has no audience?" she asked. "I put it in the plane-file drawers." "Are you happy having the work in the drawer?" And I said yes, but the more she asked me, "How could you make work and just put it in the drawer?" the harder it was to give my old answer. Susan's real question was "How can you just work for yourself?" I think I've answered her question with this book and this work.

R S But she wasn't just asking, "How come it ends up in the drawer?"; she was also sort of saying, "It comes from a drawer," wasn't she?

A C Yes, if you mean that Susan was thinking of me as the "drawer."

R S And once you made work that was more of the world, it never reached the drawer.

A C That's right. It had something Susan and other people could relate to.

R S In addition, your work became more similar to what she does, which is also a form of excavation based on accepting, examining, and then reading through a surface.

A C Yes, that is my understanding as well.

R S One of the reasons I would call your works conceptual is that Conceptual Art combined text and image, making the fusion into the work of art. Works of art have always had titles and obviously they're important. But with Conceptual Art, as with certain Dadaist and Surrealist works that preceded it, the caption became a kind of clue, or giveaway or punch line. It illuminated the work to an extent

that I sometimes find irritating because the most important information seems to come from outside the image.

Your images can have a similar visual amorphous quality. Looking at them, one gets a sense of dilapidation, of something mournful, abandoned, neglected, and, shall we say, not loved. But there's something else that you get and that's the very intense charge that comes when you see the title, which sharpens the whole thing. In his essay in this book ("Phantoms"), Jonathan Bordo writes about this transition, this closing of the gap as an important aspect of the experience of your work. The viewer repeatedly reenacts the act of recognition, of becoming conscious of something beneath the surface. It that a process that you think about? Is that an inevitable result of dealing with such charged subject matter in such a very understated way? Do you see that as a problem at times?

AC That is one of the difficulties that I also had, in the beginning, with Conceptual work—that frame of reference. It was a problem at times, yes, but it's also something now that I don't know how to—or maybe, more to the point, I don't want to—get around. It's crucial to me that the images remain understated, because that's the only way it seems to me that they can carry the history of place. The text and one's sense of history when sited are anchored; then the work calls upon memory and response and other things from people. I welcome that and I understand how it affects the work. The work that doesn't do that—maybe I can address it in another way—the work done by others in, say, Auschwitz, that doesn't need to rely on the title, often seems to me to be generic. We all know the curvature of the concrete posts that, at numerous camps, held the electrified wire.

RS Perhaps.

AC So when you see that, you think "Oh yes, this is a Nazi camp." And then the picture evaporates because of its very familiarity; its impact is dissipated because you know it is a symbol—a commonplace in the visual discussion of the camps.

RS So it becomes iconic and at the same time forgettable.

AC Yes. So I'm trying to work with the other side of this. I'm interested in dealing with history without appropriating, reinventing or transforming it or reducing it to an icon. I don't think it's my place to do that. And in the end I think we always go back to the picture. The text holds us, helps shape us, it intensifies our reaction about the picture, but it doesn't displace the picture. It's not a picture about a

word. It is about a place that is singular, and to focus with text on the image of that place only sharpens the reality of the place and then, ultimately, offers the ability to probe the depth of our own feeling toward that place.

R S But the fact that your images are relatively scientific, unmelodramatic and uniconic can also make them hard to remember. They don't differentiate themselves. They don't have a profile, an edge, and a style, like a Weston or an Adams or an Evans or a Cartier-Bresson. You have to come back to your images to remember them.

A C There are elements—or a fusion of elements—in a Cartier-Bresson picture that lead you to think about them as iconic. It is the removal of those elements (or the lack of them) from mine that I think allows another thing to happen. If each image were singular in a Westonian sense, then you would not need text, and you would not need a series. You would just have the icon from camp one, and then the iconic image of camp two—which I think most documentary photographers try to do. I think most journalistic documentary people are asked to go in and get the essence in—

R S One picture.

A C One picture. I know they are trying to give access to the union, or the conflation, really, of all kinds of things. And they are trying to give it to the viewer in one picture and that, it seems to me, offers very little room for the viewer. It allows the viewer to remember it in a singular kind of way, and to remember the artist that made it, but the viewer must align his or her thinking to the stimulus path that the image offers.

R S The phrase "room for the viewer" is interesting because a lot of those people who get it—whatever "it" is—in one picture take that picture from a place where you can never actually be. They find the vantage point from which, often, the public has no access.

A C That's right—and that is the problem. They are too often offered illustration rather than the possibility of a record, the possibility of personal meaning.

R S So, it's sort of like being presented with an image of Paris from the top of the Eiffel Tower. You actually can't get there any more, either. What's interesting in your photographs is that, to get back to this idea of space, you are exactly where anybody could be, and you never see more than they would see if they were just standing, more or less on that same spot, looking at their feet. And that's why the

word tile is so interesting to me. It's as if you're saying if you walk around here, and watch where you're going, this is what you're going to see—you're not going to be looking at any breathtaking vista or distant horizon, or even at a row of barracks.

A C You won't see more, in fact you'll probably see less, but you will see differently.

R S When you go to these places you are proceeding step by step. You are sort of saying this happened here, that happened here, which can be overwhelming, in a cumulative sense.

A C Jonathan Bordo understood that the camera sees in units of measure—and that that measure is human scaled.

R S It's interesting to think of Sontag's idea about the camera as a kind of obstacle or shield to direct experience. There are photographs that come from that attitude, in a way, where the camera fends off experience—and then there are others where it doesn't.

A C Where it's not a shield. That's right. It is a delivery system.

R S I think you make the camera especially invisible, because it's just doing a certain kind of job. You're making some decisions. I'm not discounting the aesthetic decisions at all, but—

A C In fact, I've become aware that in order to create a coherent document, each photograph of the document should offer the viewer a consistent level of visual equality. Without aesthetic or informational highs and lows, ups and downs, a viewer can look at the images and keep on looking. The consequences of looking are cumulative and that deepens the viewer's relationship to the work and to the concept of the work. The more you see, the more you are willing to accept what the pictures are addressing. The earthen commonplaces of Bergen-Belsen, Verdun, or the Berlin Wall belie the deranged activities that took place there. And the only way to stay tied to them is to have one, in a way, after another.

R S You want each one to emit an equal amount of information. You don't want the emotional charge to fluctuate, you don't want visual drama to fluctuate, you want an equivalent to a Morse code of dot dot dot, dash dash dash, dot dot dot—

A C Same intensity and harmony. Otherwise this balance, this invisibility would break down.

R S And do you think that this equality creates more room for the viewer?

AC Yes.

RS When you were using the word "document" I was thinking that there's art, and there's document, and then there's something else that's sort of almost forensic? And that—these are—they have aspects of all three, because they're not without a kind of aesthetic quality, and they're reporting the facts, and they're also offering hard-to-see forensic information.

AC But they're not reliably forensic. They are not evidential enough. And anyway, the camps already provide plenty of evidence, if that's what is wanted. The camps now are museums where they display their documentation of grotesque, horrific pictures. You're aware of history at every turn. You are often in a place looking at a display of activity that happened within that very space or area; when you turn away, you realize you are looking at the building or the crematorium of the photograph. At these places, despite everything, there's only so much time you can spend there; there is only so much horror we can take. You want to be informed but your desire to be informed punishes you. Though fiction is a perfectly wonderful vehicle for real ideas and real emotions, I am scrupulous about the truth in my photographs. I keep precise records so that I know that when someone attaches an emotion to a place, that I'm not betraying them.

RS In terms of your process of taking the picture, the death camp photographs and the Berlin Wall photographs are similar in what I call their localness, or their specificity. They preserve the shortest line between the eye and the subject, and that sense of looking at the ground one is standing on. In the photographs of the World War I battlefields, the space sometimes changes. It gets bigger and more vertical. Horizon lines are sometimes visible. How did your process change? Are you standing on anything?

AC At the World War I sites, I stood atop the trenches or other mounds and looked down. I welcomed that because it gave the land a physicality that it really deserved—that the land was really punished, and it was dug out. And it was up and down, it was leveled and then punctured again with deep craters. The horizon line better defines the degree to which the earth was pummeled.

RS The dates of the photographs made me realize that, despite what has been written about the way these three series follow a time line—World War I begat World War II which begat the Berlin Wall—this project was not done in chronological order.

AC Everything was individual.

RS Everything was individual, and backward.

AC And backward, and particalized. Atomized, actually. The idea of the camps—and their reality—drew me toward European history of the past century.

RS I'm interested in a less visible spatial shift that occurs over the course of these three series when they are taken in chronological order. In World War I there were different and extensive zones of terror and violence dispersed over huge swaths of France and Belgium; suffering was completely widespread. And then the images move to the concentration camps, which, living up to their name, are concentrated. They concentrate terror and violence in a horrible way. And I was trying to figure out how the Berlin Wall fit this progression and was initially thinking of the Wall as a division between East and West Germanys. In fact it was a division between the West, a desolate No Man's Land and the East. It was a very specific, rather narrow ribbon of land where the people who ventured into it often lost their lives. As the images proceed, the area that concerns them becomes more and more compressed and the population that suffered becomes more and more specific. You have people from all over the world in the World War I battles; and then to a very specific kind of East German who did not want to stay in East Germany.

AC And actually that's a wonderful understanding. The Berlin Wall is then actually a trench. Rather than two World War I trenches facing each other, the Wall is merely one trench, separating the Germany at war with itself on the east from the Germany in the west.

RS I see your work in the context of late Conceptualism, yet it adheres to a very pure form of early Conceptualism. One of the notions central to Conceptual Art is that reality is enough, life is interesting enough, and that—just by recording it, or presenting it nearly unaltered or modestly adjusted—you can create resonance. The reality and life that interested most early Conceptualists was fairly mundane. Your approach has been to use the same strategies, but to work with something of great significance to you and millions of other people.

This sounds dramatic, yet there is a double kind of reticence in your work. First of all that you don't want to dramatize your subject, or appropriate it in an active way, or make it iconic. Secondly, there is this regard for the viewer. You impose very little on your viewers. You present them with this seemingly mundane

neutral piece of ground that is not at all mundane or neutral and then, without a lot of fireworks or even guidance, give them access to it as a site of intense, concentrated activity. I'd never thought about the meaning of the word concentration as much as I have during this interview.

But your interest in how history is buried in the earth, or marks the earth, in how the earth absorbs these extremes of human activity, has other implications for the viewer. By extension, you're interested in all of the earth. It seems possible that there is almost no piece of ground on earth that is untouched. Some of these "concentrations" are completely enclosed, private and invisible to all but one person or a few individuals. Think of the personal history that would rise to the surface for each of us just by looking close-up at the terrain of the backyards of our childhood homes, for example. To the other extreme, there are whole peoples, whole civilizations that are gone now, whose traces disappeared from the earth's surface centuries if not millennia ago. Think of all the unknown battlefields and killing grounds that people walk on today—or for that matter pave over with parking lots. There is almost no stretch of earth that doesn't harbor some kind of concentration.

AC The concentration you describe posits history into the earth itself. That is the realization that evolved during the course of this work: ideas emerge from matter. After walking what had been the treacherous ground of the Berlin Wall and of Dachau, I understood that history, in a contemporary image, could be sited. Events could—do—become geography.

notes on the photographs

1. Martin Gilbert,
Atlas of World War I
(New York: Oxford
University Press,
1984), p. 56.

The Somme. Photographed March 1998.

The Somme was a tiny battle site of inconsequential strategic value that devoured the lives of 20,000 inexperienced British troops on the first day of battle, 1 July 1916. Preliminary to a troop advance, 1,310 heavy guns of the French and British forces unleashed a continuous bombardment of 1.7 million artillery shells at German trenches along an eighteen-mile front. The artillery assault failed to clear the earth of barbed wire or to collapse the trench bunkers of the German army that waited for advancing British and French army units unprepared for any resistance. By the time the Battle of the Somme staggered to its end in November 1916, the British had sustained 420,000 casualties, the French almost 200,000, and the Germans about 450,000.[1]

PAGES 13–18: Newfoundland Memorial Park near Auchonvillers, France. The intact trenches of this eighty-acre site expose the intimacy and brutality of the conflict. The trenches were, in places, very close—sometimes a distance no greater than forty yards. The soldiers could see and hear each other and thus know the consequences and permanence of their every action. Today, a visitor to the memorial site knows from looking what despondency guided Isaac Rosenberg to

write "Death waits for me—ah! who shall kiss me first? / No lips of love glow red from out the gloom / That life spreads darkly like a living tomb / Around my path."[2]

2. *The Collected Works of Isaac Rosenberg: Poetry, Prose, Letters, Paintings and Drawings*, ed. Ian Parsons (Oxford University Press, 1979), p. 8.

PAGE 19: The cratered German front line on Vimy Ridge.

PAGE 20: A small British cemetery of unknowns near Albert. Perched atop a promontory on a bank of the River Meuse, the third-century Roman town of Verdun—its Gallic name means "powerful fortress"—became, by treaty, part of France in the seventeenth century. Despite its long history as a regional commercial center, Verdun is now the embodiment of the unregulated devastation of modern war. Verdun experienced, as no other place in Europe, the transmogrification of pastoral earth into barren, pulverized lunar forms. Without interruption for ten months beginning in February 1916, and then continuing sporadically for two years, the land and the inhabitants of a compact area around Verdun were ravaged by interrupted artillery bombardment. Nine villages were obliterated. All physical evidence of the more than 700,000 casualties was eradicated by the icy mud and one or more of the 115 shells that, on average, slammed into the ground each minute of every hour of every day for five months. Today, areas around Verdun remain volatile and useless because of the twelve million unexploded shells still buried there.[3]

3. Gilbert, *Atlas of World War I*, p. 53. John Keegan, *The First World War* (New York: Vintage, 2000).

Verdun. Photographed March 1998.

PAGE 21: Atop the strategic Fort de Vaux, the vegetation of this landscape exploded into fire because of sustained attack by flamethrower and poison gas.

PAGE 22: The site of prolonged and fierce attack along the top of Fort de Douaumont. An anonymus Allied pilot wrote, "Every sign of humanity has been swept away. The woods and roads have vanished like chalk wiped from a blackboard; of the villages nothing remains but grey smears. During heavy bombardments and attacks I have seen shells falling like rain."[4]

4. Anthony Livesey, *The Historical Atlas of World War I* (New York: Henry Holt), p. 108.

PAGE 23: Battlefield ground at the Ossuary of Douaumont.

"On the worst battlefields . . . 1,000 artillery shells fell per square meter of battleground. Fitting with the general rule that 15 percent of the projectiles fired in that war didn't blow up, that means 150 of the projectiles of those 1,000 shells can

still exist in a square meter. In some places, unexploded artillery shells are thicker in the ground than pebbles."[5]

PAGE 24: At Fort de Vaux.

PAGE 25: Atop Fort de Douaumont.

PAGES 26–27: Gnarled barbed wire strands atop Fort de Vaux.

PAGES 28–29: The plowed landscape near Bois d'Ailly. Over the horizon is a *Zone Rouge* landscape too dangerous to walk.

Auschwitz. Photographed May 1994.

PAGES 31, 33, 36: The interior streets of Auschwitz I—a former Austrian artillery barracks complex—were made of large stones that were recycled into local structures immediately after the camp was liberated and rebuilding began in postwar Poland.

PAGE 34: At the entrance of Crematorium I.

PAGES 32, 37: At night the electrified fences carried high-voltage current.

PAGE 38: Under the gallows. The shadow of the reconstructed gallows is on the right. The twin top-to-bottom trace bisecting the picture was made by water falling, drop by drop, from the gallows bar directly overhead.

PAGE 39: In the camp, under the shadow, on a sunny day, of the *Arbeit Macht Frei* legend atop the iron entry gate, hordes of touring groups reconvene. In group after group, when told they will be going directly to Crematorium I, visitors invariably align themselves in pairs for the procession and walk this narrow path down the middle of a wide street.

Auschwitz–Birkenau. Photographed May 1994.

Seven contiguous Polish villages—Babice, Budy, Rajsko, Broszkowice, Plawy, Harmęże, and Brzezinka—were demolished in 1941, in a 15.5 square mile area, to build and hide within that prohibited zone a second killing center near Oświęcim, Poland. The Nazis named the center by its location. It was, at first, Auschwitz II and then, later, Auschwitz-Birkenau (from Oświęcim-Brzezinka).[6]

PAGE 41: The railroad ties are directly under the entry portal to the camp. The

5. René Teller, head of the Technical Center, Département du Déminage, 1996. Quoted in Donovan Webster, *Aftermath: The Remnants of War* (New York: Pantheon, 1996), p. 52.

6. Israel Gutman, ed. *Encyclopedia of the Holocaust* (New York: Macmillan, 1990), p. 108.

orbit of life for the inhabitants of the transport trains was forever changed after crossing this threshold.

PAGE 42: The remnants of the chimney system within the barracks.

PAGE 43: The dynamite-damaged external sidewall of Crematorium II.

PAGE 44: The exposed, central concrete strip that linked chimney to barrack floor.

PAGE 45: A building base from the men's isolation area.

PAGE 47: The first earth touched by prisoners as they exited the transport trains. This is the "platform"—called the *rampa*—between the two sets of special rail siding tracks within the camp. Each track is almost equal in length to the width of the camp—six-tenths of a mile—and would therefore have been able to support delivery of nearly eighty boxcars per train.[7] The number of individuals arriving on this *rampa* per year made it the busiest railroad platform in Nazi-occupied Europe. And the flow of traffic on the *rampa* was unidirectional—arrivals only.

Dachau. Photographed September 1992.

". . . of the ground in Dachau, site of one of Hitler's concentration camps, . . . the trace remaining of the wall [is] . . . the *res* of history, its material reality. . . . We have been surfeited for a half a century now with horrific images of concentration camp dehumanization, stories of children, survivors, thefts, of rationalizations convincing or wan. . . . [This ground] evokes for me . . . a human horror even greater than the carnage—the knowledge that the events it recalls were a choice. In this knowledge lie the tears of our times . . . of all history."[8]

PAGES 49–51: These barrack plinths define the outline of buildings that housed perhaps as many people inside, over time, as there were stones beneath.

8. Stephanie Quinn, ed., *Why Vergil?* (Wauconda, Ill.: Bolchazy-Carducci, 2000), p. 428.

Sachsenhausen. Photographed May 1994.

The colorless remains of the concentration camp Sachsenhausen, established in 1936 and now a Gedenkstatte, or museum site, is located about one hour, by car, north of central Berlin. The camp's functions by 1994 were unknowable because the site's buildings—the barracks and work structures—had all but dissolved. The

grotesque objectives of Sachsenhausen are today impossible to impute from the series of freestanding walls or the exposed concrete floors that resembled tectonic plates upon a sea of coarse gravel.

"The task of urbanizing the territories formerly connected with the Sachsenhausen concentration camp raises the most fundamental political, cultural and spiritual issues of the twentieth century. What must be faced in any endeavor to recreate and redevelop such an area is the need to mourn an irretrievable destiny to reveal, disclose and remember."[9]

PAGES 53–57: The ground at this skeletal camp has retained the lines and planes of buildings dismembered long ago. Here, the earth endures as the architectural template.

Bergen-Belsen. Photographed June 1994.

PAGES 58–59: This open terrain, now returning to nature, was the death camp Bergen-Belsen. The landscape within the camp's boundaries is now dominated by the numerous and enormous mounds that are the mass graves. It is an uncharacteristic landscape for northern Germany, resembling more the sites along the Mississippi River where, for almost four thousand years (until 1500) the American Woodland Indians sculpted their complex earthen mounds for funerary and religious ceremonies.[10]

Ravensbrück. Photographed May 1994.

PAGES 60–61: The restored grounds and the wall of the crematorium building of this camp established for female prisoners.

Buchenwald. Photographed June 1994.

Rather than take the name of the city, town, or region where it was located, *Buchenwald* was a name given to this massive camp by Heinrich Himmler, head of the SS. Sited in the hills above Weimar, the camp was, after liberation, in the custody of the Soviet Union and the German Democratic Republic, where it was

9. Daniel Libeskind, *Radix-Matrix: Architecture and Writings* (Munich and New York: Prestel, 1997), p. 102

10. Douglas C. McGill, *Michael Heizer: Effigy Tumuli: The Reemergence of Ancient Mound Building* (New York: Abrams, 1990), p. 45.

caught between multiple impulses: to restore, to demolish, to reconstruct, to fabricate, to memorialize, and to ignore. Their solution seems, from the condition of the camp, to have been to exercise all of those contradictory impulses simultaneously.

PAGES 62–65: The trace evidences everywhere of camp buildings.

PAGE 67: So little life is now evident at the killing centers that this patch stands apart from the desolate barrenness everywhere in the camp system.

The Berlin Wall. Photographed August 1992, May 1994, May 1996.

"The border between the two German states, and especially between the two halves of Berlin, is considered the world's most closely guarded and the most difficult to cross. The ring around West Berlin is 102.5 miles in length. Of this, 65.8 miles consist of concrete slabs topped with pipe; another 34 miles is constructed of stamped metal fencing. Two hundred sixty watchtowers stand along the border ring, manned day and night by twice that many border guards. The towers are linked by a tarred military road, which runs within the border strip. To the right and the left of the road, a carefully raked stretch of sand conceals trip wires; flares go off if anything touches them. Should this happen, jeeps stand ready for the border troops, and dogs are stationed at 267 dog runs along the way. Access to the strip from the East is further prevented by an inner wall, which runs parallel to the outer Wall at an irregular distance. Nail-studded boards randomly scattered at the foot of the inner wall can literally nail a jumper to the ground, spiking him on their 5-inch prongs. . . . Underground in the sewers, the border is secured by electrified fences, which grant free passage only to the excretions of both parts of the city."[11]

11. Peter Schneider, *The Wall Jumper: A Berlin Story* (Chicago: University of Chicago Press, 1998), pp. 52–53.

PAGE 69: In Kreuzberg, Bethaniendamm near Adalbertstrasse.

PAGE 70: In Pankow, near Schonholz at Buddestrasse.

PAGES 71–73: The street between the Reichstag and the Brandenburg Gate.

PAGE 74: On Zimmerstrasse, east of Friedrichstrasse and the crossing point known as Checkpoint Charlie.

PAGE 75: Checkpoint Charlie. The intersections of Zimmerstrasse and Friedrichstrasse.

PAGE 76: Near the Brandenburg Gate.

PAGE 77: On Sebastian near Prinzenstrasse.

PAGES 78–79: Lindenstrasse construction between Zimmerstrasse and Kommandantenstrasse.

PAGES 80–81: The street between the Reichstag and the Brandenburg Gate.

PAGE 83: In Treptow, at Lohmülenstrasse. The path of the Wall is at the middle top of the frame.

PAGE 84: Flower petals where Chausseestrasse and Liesenstrasse intersect.

PAGE 85: The Oberbaumbrücke over the Spree. The tracks were severed on the roadway of this East Berlin bridge where the Oberbaumbrücke touched the Spree's riverbank and thus the boundary of West Berlin.

PAGE 86: The steps of Checkpoint Charlie at Zimmerstrasse and Friedrichstrasse.

PAGE 87: The stones mark the Wall path near the Martin-Gropius-Bau.

PAGES 89–90: Alexandrinenstrasse near Stallschreiberstrasse.

PAGE 91: Near the Martin-Gropius-Bau.

PAGE 92: Lindenstrasse construction between Zimmerstrasse and Kommandantenstrasse.

PAGE 93: Embedded in the surface of Niederkirchnerstrasse, one of the perimeter streets of the square block that contains the Martin-Gropius Bau and the "Topography of Terror" Museum, is this commemorative, engraved metal stripe that now represents the boundary, the deconstructed border between what had been East and West.

acknowledgments

This book exists because of my wife, Susan Walsh. Her abiding love, life-enriching friendship, and unfailing support have sustained me since the making of the very first picture. Her gifts to me of an intellectual partnership, an enduring optimism, passion for travel, and new ways to understand my own thoughts have invigorated my work and brought me great pleasure. I am blessed to have her in my life.

The idea for this book emerged from conversations between Susan Bielstein and Alan Thomas. I will be forever grateful for the privilege of working with these two extraordinary professionals. To Alan, my editor, I offer special thanks. He has become, in the years required to make this book, a most cherished friend. I am the lucky recipient of his refined eye, his passion for photography, and his keen mind. I am more grateful to him than I can communicate or demonstrate; my debt to him is beyond calculation.

Jill Shimabukuro has transformed a pile of pictures and a ream of text into this carefully structured object of beauty. I cannot envision a better architecture for these images. I thank her for focusing her prodigious talents on this project. I salute and thank Jennifer Moorhouse for her keen devotion to the details of truth and the elements of style. I am grateful to and thank Virginia Allen for so gra-

ciously, quickly, and skillfully transcribing hours of interview tape into narrative text.

Every career is the confluence of timely help and gracious hope. I have been honored by the support of wonderful friends, esteemed colleagues, generous bene-factors, and loyal family. For their crucial publication support, I profoundly thank Ann Rothschild, Claudia and Steve Schwartz, Annie and Lewis Kostiner, Sandro Miller, Claudia Luebbers, Irmgard Hess Rosenberger and Dean Carol Becker on behalf of the School of the Art Institute of Chicago. I am especially indebted to Ann Rothschild for her generosity over the past twenty-five years. For their belief in the work, editorial suggestions, aesthetic perceptions, willingness to educate me and, above all, for their friendship, I thank (in alphabetical order) Jonathan Bordo, Alfonso Carrara, Sander Gilman, David Krell, Daniel Libeskind, Joerg Metzner, Michael Naas, Stephanie Quinn, George Roeder, Kathleen Slomski, Joel Snyder, Roberta Smith, Bob Thall, Julia Thomas, Lisa Wainwright, and Jay Wolke.

Artists need the extraordinary talents of perceptive and educated art profes-sionals to help them organize, display and present their art. The work within this book has been shepherded, over time, into the public domain by museum direc-tors David Mickenberg and Gregg Knight, gallery directors Eleanor Barefoot, Gerd Sander, and Carol Ehlers, editor-artist Reginald Gibbons, and conductor Joachim Martini.

In the best of circumstances, careers are shaped and supported by family. Many thanks to my nephew Jonathan Walsh for his immeasurable help as my photographic assistant both here and abroad. I value his warm companionship and joyful humor and our shared taste for good books, spirited walking, nice pens and chocolate. I thank my sister Sharon Cohen and my cousin Moss Cohen, whose total belief in my work has meant so much to me over all the years of my professional life. And I thank my father Robert, who, if he were living, would, I am certain, carry the book everywhere and show it to everyone as the object that confirms growth through change.

I teach at two wonderful academic institutions in Chicago—the School of the Art Institute of Chicago and the School for New Learning at DePaul University—that have supported my work through travel and research grants. I thank Simon Anderson, Carol Becker, Victoria Engonopoulos, Tony Jones, Stanley Murashige,

and Tom Sloan of the School of the Art Institute, where art and scholarship are endorsed with equal and sustained enthusiasm. I thank Corinne Benedetto, Susanne Dumbleton, David Justice, and Donna Younger of the School for New Learning for creating and sustaining an environment where teaching is valued and nourished.

Over the years an extraordinary group of devoted interns shared their vibrant energy and formidable skills to help process, print, organize, document, and evaluate the work within this book. To (in alphabetical order) Scott Becker, Shaina Boone, Josh Brand, Jill Brooks, Alexis Burdette-Hunt, Bradley Conway, Genesis Floater, Douglas Foster, Justin Goh, Anthony Polakowski, Linda Ramirez, Jordan Schulman, Sam Solomon, Christina Van De Berg, Anne Wells, and Mark Werle I offer my profound thanks. — ALAN COHEN

The exhibition accompanying this volume is one in a series at the new Mary and Leigh Block Museum of Art relating to aspects of the history of documentary photography. Presented in the Alsdorf Gallery, the exhibition is the result of the efforts of many who have intrinsically understood the importance of Alan Cohen's work to a broad spectrum of issues that have been the concern of the museum. The Block is indebted to Alan Cohen for his willingness to make his work available to the museum's varied audiences. The museum is equally indebted to Alan Thomas at the University of Chicago Press for his support and understanding of Cohen's work; he is responsible for a truly remarkable book.

No exhibition occurs without the coordinated teamwork of an array of individuals in the curatorial, education, development, and administrative areas of the museum. As with many of the projects of the museum, a special thanks must go to the Illinois Arts Council, a state agency, and the Institute of Museum and Library Services, a federal agency, and to the Friends of the Mary and Leigh Block Museum of Art for their support. Dabney Hailey, curatorial assistant at the Block, has coordinated almost all aspects of this project and has been responsible for many of the programs held in association with the exhibition. She has been remarkably creative and insightful. Jane Friedman, curatorial assistant at the mu-

seum, has also helped with many of the programs held in conjunction with this exhibition. Brooke Dierkhising has worked with me, Alan Cohen, and almost everyone else involved in this project, and has been of immense assistance to all. Mary Stewart, Carole Towns, Dan Silverstein, and Debora Woods have worked on the curatorial, administrative, and installation activities related to the exhibition and have done much to make this project successful and accessible. It has been a pleasure to work with all of them. – DAVID MICKENBERG

about the photographer and authors

ALAN COHEN is adjunct associate professor of art history, theory, and criticism at the School of the Art Institute of Chicago, as well as a visiting professor at DePaul University. His work is held in more than fifty public collections, including the Metropolitan Museum of Art, the Corcoran Gallery of Art, the San Francisco Museum of Modern Art, the Philadelphia Museum of Art, and the Smithsonian Institution.

SANDER L. GILMAN is a distinguished professor of the liberal arts and medicine at the University of Illinois in Chicago and the director of the Humanities Laboratory. A cultural and literary historian, he is the author or editor of more than sixty books. His most recent monograph, *Making the Body Beautiful: A Cultural History of Aesthetic Surgery* (Princeton University Press), appeared in 1999.

JONATHAN BORDO teaches aesthetic theory and philosophy in the Cultural Studies Program at Trent University, Canada. His recent essays include "Picture and Witness at the Site of the Wilderness" in *Critical Inquiry* (winter 2000). Bordo is completing a monograph titled *The Landscape without a Witness* and a collection of writings in aesthetic theory and the visual arts.

ROBERTA SMITH is an art critic for the *New York Times*.